The Gibson Building and adjacent buildings, 1994

City Abandoned

Charting the Loss of Civic Institutions in Philadelphia

Vincent D. Feldman

Paul Dry Books
Philadelphia

Page i, Entrance Relief, Engine 16, 1040 Belmont Avenue, 1995

First Paul Dry Books edition, 2014

Paul Dry Books, Inc.
Philadelphia, Pennsylvania
www.pauldrybooks.com

Designed by 21xdesign

1 3 5 7 9 8 6 4 2
Printed in China

CIP data available at the Library of Congress
ISBN-13: 978-1-58988-082-5

Contents

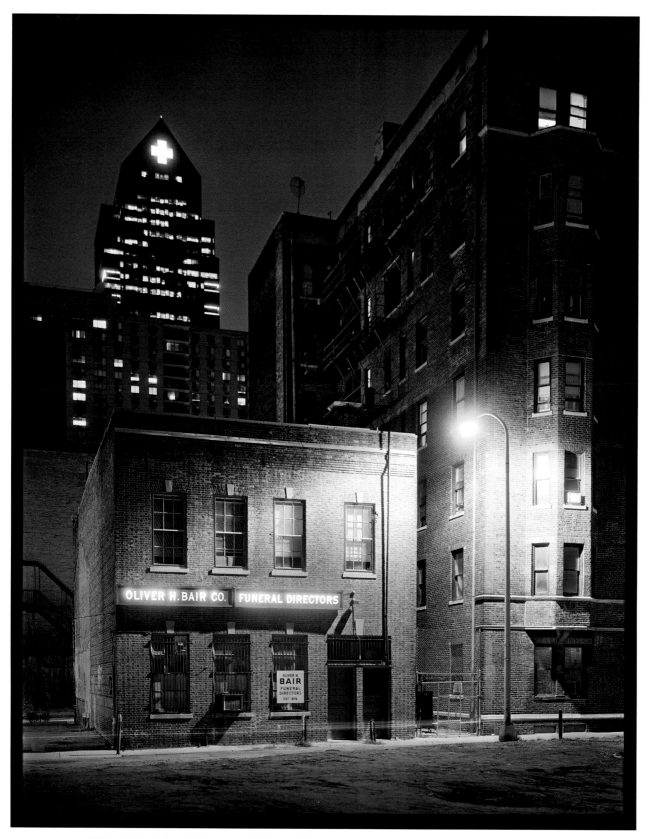

Oliver Bair Funeral Home and Warwick Apartments, 1997

On Vincent Feldman's Philadelphia
By John Andrew Gallery

Sometime in the mid 1990s, I am not really sure what year it was, I went to the annual juried art show at the William Penn Charter School, which both my sons had attended. I was hoping to find something that I liked and could buy as a way of making a contribution to the school. Over the years, my modest collecting interests had focused on photography, and so it was a photograph I most hoped to find.

The show was filled with paintings and drawings, with pottery and jewelry, but there seemed to be very few photographs. At last I found one that immediately caught my eye, and which, I then or later learned, had won first prize. The photograph was large, as I recall — perhaps a 16 x 20 black-and-white print. It had been taken at night and showed what appeared to be the backs of two small buildings along an alley, both illuminated by the faint light of a street lamp. One building had a sign on it for the Oliver Bair Funeral Home; the other, only partially shown, appeared to be a nondescript five- or six-story apartment building with bay windows.

I was drawn to the photography, not just because it was a striking image, but also because it reminded me of the time when I had just moved to Philadelphia and spent many evenings wandering alone down narrow alleys, similarly lit by street lamps, among similar buildings in the Old City neighborhood where I lived. I could tell from the Oliver Bair sign and the illuminated Greek cross floating high in the sky above—the symbol of Blue Cross atop its office building a few blocks away—that this was not Old City but someplace close to Rittenhouse Square. Nonetheless, the photograph filled me with nostalgia for that period in my life and the carefree nights I spent prowling through the city I had just moved to and knew little about. Perhaps because of these memories, perhaps because of the quality of the light, I found the photograph to be what I could call somewhat "romantic." The buildings seemed in good condition, and since the photograph was taken at night, the residential building might have been filled with people who had turned out their lights and gone to bed before the photographer arrived.

I didn't end up buying the photograph, but the photographer's name stuck with me: Vincent Feldman.

In subsequent years, I began to see other photographs by Vincent Feldman in exhibitions, photo contests, the annual report of a local foundation, and other places, although I can't recall exactly where. These photographs were quite different from the Oliver Bair (as I called it in my memory). They were not romantic at all; they were much darker, almost sinister images of vacant buildings throughout the city. I was

very familiar with the abundance of vacant and abandoned buildings in Philadelphia. As director of the City's Office of Housing and Community Development (OHCD) in the late 1970s, it had been my responsibility to try to find a way to rehabilitate some of them—mainly residential rowhouses. It was estimated that even then there were twenty or thirty thousand scattered throughout what was referred to as the inner city, that ring of neighborhoods immediately around Center City and especially the area to the north, North Philadelphia. I traveled through these neighborhoods for several years trying to make subtle distinctions between places that seemed too far gone to save and places where our meager funds might make a difference. It was a depressing experience and often sent me home feeling hopeless about my ability to have any meaningful impact.

Vacant rowhouses were not the only problem. There were many types of vacant buildings, including large loft buildings concentrated in the eastern section of North Philadelphia known as Kensington, which had once been the center of the city's enormous textile manufacturing industry. Among these was the Stetson Hat Company, manufacturer of the famous cowboy hat. Stetson once employed 5,000 people in 25 buildings in the area. The company started a school, a hospital, and a building and loan fund for its employees. When it followed the path of other textile companies and closed in 1971, the community lost not only jobs, but also an institutional infrastructure that had been essential to its stability. The City had inherited the complex of buildings, and one of my responsibilities was to oversee what to do with them. As an architect, I loved these loft buildings, particularly Stetson's main building, which was triangular in shape and had a high clock tower at an apex, which was a distinctive landmark in the neighborhood. But over the years, I acquiesced to the advice of others that the buildings were not suitable to current commercial needs and allowed them to be demolished one by one, the clock tower succumbing to a fire in 1980.

The occasional Vincent Feldman photograph I saw served to remind me of a side of Philadelphia that was in stark contrast to the revitalization going on in Center City, which had begun in the 1950s and continued into the 1970s, 80s, and 90s. I was painfully aware of the difference between these two worlds because my work at OHCD and subsequently as a consultant focused on these neighborhoods and these buildings.

Although Vincent's photographs were an occasional reminder of this other aspect of Philadelphia, I did not think seriously about them until the early 2000s when I became executive director of the Preservation Alliance for Greater Philadelphia, the city's primary nonprofit advocacy organization for historic preservation. Knowing how many architecturally distinctive historic buildings were vacant in the city, I wanted to find a way to draw greater public attention to this situation. I started to publish an annual Endangered Buildings list and thought that an exhibit or some use of Vincent's photographs would contribute to this effort. So one afternoon I spent a few hours with him at his studio looking at dozens of large-format prints of the buildings he had been

photographing since the mid 1990s, including my old friend Oliver Bair. I came away from that visit feeling more depressed than I had before.

Vincent Feldman's photographs *are* depressing. Therein lies their power and meaning. I am convinced that he waits for the gloomiest, most overcast days to go out and take his pictures, days so bleak that no other human being is likely to venture outside and wander inadvertently between his camera and the building that has caught his attention that day. His artistic approach is designed to capture in a photographic print the feelings of despair that he—and many others including myself—feels when seeing these beautiful buildings in their deteriorated state. The black-and-white images, the printing of the full negative edges, the lack of sunlight and people, the muted gray and black tones of the images are all deliberately chosen to create this emotional response in the viewer. And they are remarkably successful in doing so. They explicitly pose the question: How could buildings of such architectural beauty have fallen into this state of abandonment in the fourth largest city in the country in the later part of the 20th century? How could they be allowed to remain in this condition? Perhaps these questions were more painful and more pointed for me because of my job: they presented an inventory of architectural monuments that I would spend the next ten years trying to revive.

As Vincent's notes in his comments on the photographs in the appendix indicate, each building has its own story of both decline and revitalization. There is no simple answer to how these buildings fell into their decrepit condition, but there were some large-scale forces that created conditions that influenced all these buildings and their decline.

Philadelphia City Hall was begun in 1871 and called "finished" in 1901, although worked continued until 1909. Its construction marked a period in which Philadelphia was referred to as "the workshop of the world," a period that produced enormous economic growth and one that created wealthy industrialists, attracted new residents to the city, and created an affluent middle class. In 1908, the committee responsible for organizing the celebration of the 225th anniversary of the founding of Philadelphia published a poster that showed an aerial view of the city accompanied by a list of facts demonstrating Philadelphia's claim to that title. This list is extraordinarily impressive. At the time, Philadelphia had 16,000 manufacturing plants employing 250,000 people; it was the country's leading producer of locomotives, carpets and rugs, leather, hosiery and knit goods, street railway cars, iron and steel ships, felt hats, and saws. More tonnage of steel ships was produced in the city than in the rest of the country as a whole; each year, 45 million yards of carpet were created, 4.9 million hats, 180 million yards of cotton goods, and enough woolen goods "to make uniforms for all the armies of Europe now in service." And the list goes on.

This enormous economic engine attracted workers to the city, increasing the population to 1.5 million and creating substantial growth: of the city's 342,000 buildings

in 1908, twenty percent had been constructed in the previous ten years—houses, churches, schools, hospitals, and a variety of civic buildings. Wealthy industrialists were also real estate developers, producing architecturally distinctive housing for the growing urban middle class, designed by the leading architects of the period. And the city had tax revenues sufficient to enable it to build distinctive schools and other public services.

City Hall not only marks this period of the city's growth, its architectural exuberance also reflects the architectural richness of the period. While today Philadelphia is best known for its colonial history and distinctive buildings associated with the founding of the nation, Philadelphia's greatest architectural heritage—and probably most underappreciated—is that of the late 19th and early 20th centuries. When Vincent went out to photograph the city virtually one hundred years later, he found the relics of this period. His photographs often seem to be of buildings of classical antiquity, covered with ivy and weeds, fragments of a civilization that has collapsed and from which all inhabitants have fled. Although this may paint an extreme picture of Philadelphia in the late 20th century, it is not entirely untrue.

As happened to many older cities, the Great Depression and Second World War affected Philadelphia's prosperity. The war actually created a temporary boom, with local manufacturing companies producing a large percentage of the nation's war materials. This growth attracted workers, and the city's population peaked at just over two million in 1950. But manufacturing never recovered after the war ended, and the population began to decline even while civic and political leaders were creating revitalization plans for the city based on the assumption that it would reach 2.8 million by 1980. The City's plans focused primarily on the ambitious redevelopment of commercial and residential areas of Center City. At the same time, it undertook two other major development initiatives that inadvertently contributed to the decline and abandonment in inner city neighborhoods. The first of these was the expansion of residential development in the Far Northeast section of the city, an area that had been relatively undeveloped farmland until the 1950s. In order to capture the housing demand created by returning veterans with FHA mortgage financing, the City worked with developers to create subdivisions that would, in a short period of time, create thousands of housing units. A second, smaller but nonetheless significant initiative was the creation of a new residential community in Eastwick in the southwest section of the city. The end result of both efforts was that thousands of new houses were added to serve a dwindling population now spread over a geographic area twice the size of the area occupied by the city in 1908. It is not surprising that the older sections of the city suffered, particularly those from which jobs had also disappeared. By 2000, the population had dropped by 600,000, and while much has been made of a small population increase in 2010, the fact remains that the population of the older sections of the city is still declining, creating additional abandonment. In recent years, the Catholic archdiocese has

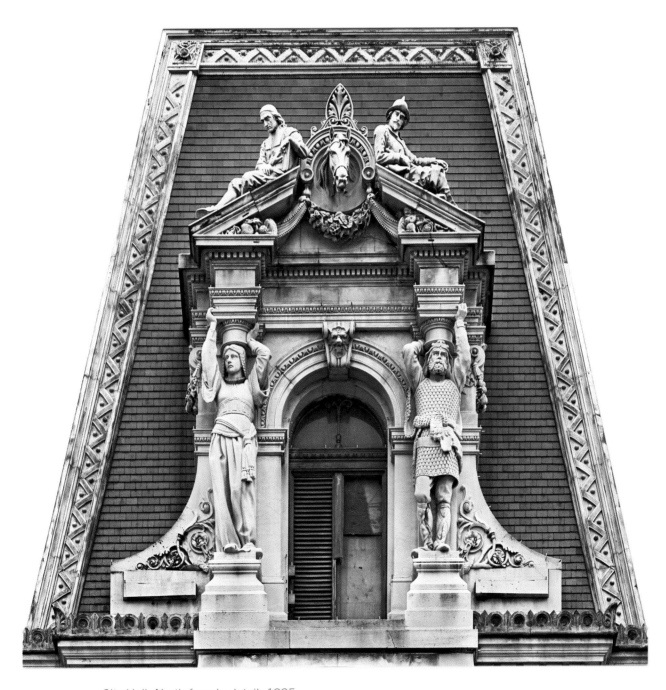

City Hall, North facade detail, 1995

announced the closing of schools and consolidation of churches; the School District of Philadelphia has announced that it will close more than twenty schools in the next few years; and the City itself has suggested that it may need to close some fire stations, libraries, and health centers to address its budget problems and adjust to the current population size and distribution.

I mentioned that Vincent's body of work created almost a checklist for me when I was executive director of the Preservation Alliance. Strangely enough, one of the earliest buildings I set out to save was the Oliver Bair Funeral Home, along with its neighboring apartment building, which I had first seen in Vincent's photo. Although not the most important historic buildings in the Rittenhouse Square area, there were important legal precedents involved that led me to spend three years in court to successfully prevent their demolition. Alas, they remain vacant today.

Many of the buildings Vincent has photographed have been preserved and adapted to other uses, and some have been given legal protection but still remain vacant. Often a building was saved not because of its location (the factor realtors frequently cite as the most critical in real estate) but because of timing. It has been said that if an historic building can survive long enough its time will come, and for many of these buildings that has been the case. Take for example Biddle Hall, the central building of the former U.S. Naval Home. It had been vacant for twenty-five years in spite of the efforts of community organizations to get the owner to restore it. In 2003, a small fire in the building provoked concern that the owner would use that opportunity to try to demolish the building and that the City would go along. Those concerns led me to contact Mayor John Street to pressure him into pressuring the owner to restore the building and not demolish it—which I am pleased to say he did. But that was not the critical factor. The fire occurred just at the time Philadelphia was experiencing a boom in condominium development. The economic conditions were right (as they had not been in previous years), and so community and civic pressure found a favorable response from the owner, Toll Brothers, which restored Biddle Hall as a focal point of a substantial new residential community.

The condominium boom was also the factor that resulted in the rehabilitation of the Victory Building, once the highest priority preservation issue in the city and one that had come close to demolition. The same was true of the Board of Education Building on the Benjamin Franklin Parkway. The search for a site for a new high school for the creative and performing arts resulted in the rehabilitation of the long-vacant Ridgway Library, the very first building that Vincent photographed. The Nugent Home for Retired Baptists was saved by the last-minute efforts of three local community organizations and the Preservation Alliance, who banded together to get it and the adjacent Presser Home for Retired Musicians listed on the Philadelphia Register of Historic Places and thereby protected from demolition. But it would take six more years for the right timing of market demand and available financing to come along to get the

buildings rehabilitated. These and many others were saved by accidents of good timing, which could not have been predicted or planned.

Of the many buildings Vincent photographed that I had some hand in preserving, my favorite is the Fairmount Water Works. It is also my favorite Vincent Feldman photograph and the one I own. It captures the sad state of the Water Works buildings with the swirling waters of the Schuylkill River in the foreground, giving it a romantic quality that, to me, makes it stand out among his other photographs. Everyone had always wanted to see a restaurant in the building because of its wonderful setting on the river. A restaurant developer proposed adding a large, Victorian-style greenhouse addition to the historic structure, claiming it was the only feasible economic solution. Having heard of this at the last minute, I presented myself at the Fairmount Park Commission meeting where the plan was being discussed and expressed strong opposition, which was subsequently joined by many others. As a result, the commission sought proposals from other developers leading to the creation of a wonderful restaurant without the need for any exterior alteration to the historic structure, which is a designated National Historic Landmark. It too had waited for its time to come.

In spite of the positive outcomes for many of these buildings, others have been demolished, and many remain in precarious condition. I lie awake at night and worry about the Divine Lorraine, fearing that the series of small fires in recent years will lead to something more substantial and less beneficial than the fire at Biddle Hall.

And of course, there are many other architecturally beautiful buildings that are vacant and abandoned in Philadelphia beyond what Vincent has photographed.

Buildings are not only important for their architectural beauty; they are also the physical embodiment of our collective history, of the people who have come before us—their aspirations for the city and the accomplishments they pass down to us to care for. By focusing on buildings that embody the civic aspirations of decades past and by portraying them in such stark terms, Vincent Feldman has created a body of work that is a vivid reminder of the fragile nature of what we have inherited and the need to remain ever diligent in its preservation.

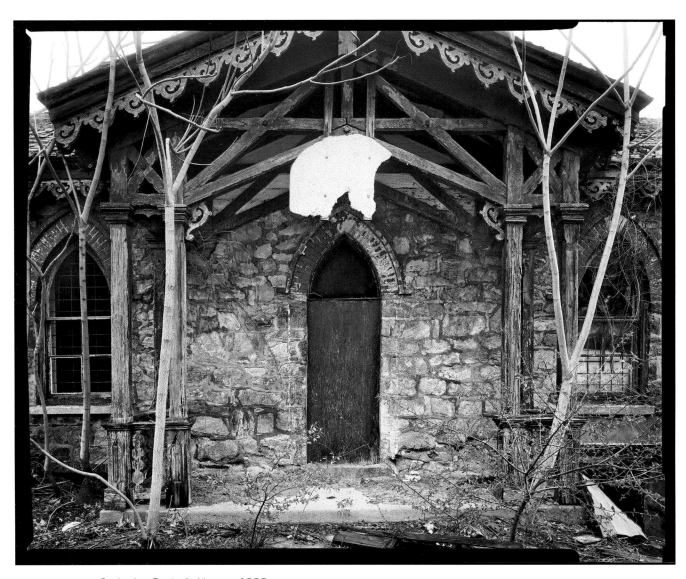

Sedgeley Porter's House, 1995

Looking at the Past
By Kenneth Finkel

In *City Abandoned*, Vincent Feldman asks us to step back from the Philadelphia we know—its color, sounds, and smells—and travel with him through a parallel world of rich tones, extraordinary compositions, and grit-infused definition to explore the past and present on *his* terms. But Feldman never asks us to leave Philadelphia behind. To the contrary, his often beautiful and compelling images move us to a deeper feeling and understanding of the city, as they pose important questions about our stewardship and the city's future. It's the story of a city on the edge, and we're glad to be along for this freeze-frame journey of photographic brinksmanship.

City Abandoned celebrates dignity in the battered forms of buildings and institutions. It acknowledges flaws alongside accumulated fragments informed by older signage (or newer graffiti) in equal measure and meaning. Feldman works with irony but doesn't let the merely ironic cloud his approach. He's got much more to see and to express. In Feldman's compositions, symmetry becomes a strategy for taming reality, a measure of control over chaos. Deep inside the images, however, in detail far more revealing than observation on the street allows, we see evidence of disturbing disorder. These devices of composition and content are reminiscent of the works of Piranesi, or Escher. And they are reminiscent of the contemporary trend called "ruin porn."

What, exactly, is ruin porn, and how can it help us understand Feldman's *City Abandoned*?

After decades of decline, de-industrialization, population shrinkage, and neglect, the urban landscape has taken on a familiar patina typical in many American cities. In the 1980s, long before the idea of ruin porn emerged, Camilo J. Vergara and others photographed cities as sociologists and documentarians. Only in 2009 did Thomas Morton inadvertently dub the genre "ruin porn" in a blog post: *Something, Something, Something, Detroit: Lazy Journalists Love Pictures of Abandoned Stuff.*[1] Then, thanks to Detroit and the Internet, we suddenly found ourselves with a swirling new genre of urban imagery.

John Patrick Leary explained "Detroitism" as an "exuberant connoisseurship of dereliction," an "unemBairassed rejoicing at the 'excitement'" that every public building, every "windowless station has become a melancholy symbol of the city's transformation in death." The images and their audiences confirmed the collective response: "The city is a shell."[2] An interesting shell to explore, but a shell nonetheless.

The ruin porn movement, however, is not really about photography or history, or the future. Photographs *may* be well crafted, but "what counts, even more than the

quality of the image" wrote bfp at the *Feministe* blog, "is dramatic presentation and, like the better-known form of pornography, 'the nakedness of the subject.'"[3] Ruin pornographers tend to be voyeuristic, which Feldman is not, and they aren't particularly concerned with quality, which Feldman is. His dedication to composition, to scale and detail, his choice of black and white, his commitment to large format photography, aligns more closely with the 19th-century landscapes of Timothy O'Sullivan and Carlton Watkins than with the work of fence-hopping hipsters intent on displaying decay on Flickr or Tumblr. Feldman is in the urban hunt-and-capture game, but his discourse with his subjects, his visual treatise on the city as a whole, is more that of stakeholder than trespasser. Feldman's images raise the deeper questions. He uses his art "to get to the root of the idea that the American city is sick."[4] Feldman is an insider, a visual investigator taking on the whole of the city, year after year, while asking questions that grow increasingly more penetrating.

If there are *any* similarities between Feldman's photographs and those made by the practitioners of ruin porn, it is in the realm of social commentary. Feldman agrees that Philadelphia, like Detroit, "has had a leg kicked out from under it," but he considers ruin porn "smothering." He believes it brands the city as a place to avoid engagement, when, in fact, Philadelphia isn't a ghost town and its citizens aren't zombies. Philadelphia is a city with a utopian legacy that remembers past and purpose.

In Philadelphia, the line of inquiry and commentary about past and purpose has its own long and venerable tradition. Over time, writers and image-makers monitoring the city have shaped and reshaped its identity. They've commented on many things, but at the very heart of it, each has weighed in on the successes and failures of Philadelphia as a "holy experiment," the city's original, ambitious, and proud legacy.

From the start, Philadelphia evolved as the *only* American city based on the belief that God inhabited its inhabitants, *all of them*, no matter what their religion. When it came to "freedom of conscience," everyone was to have an equal share. Founder William Penn intended that Philadelphia be more than just another city; he worked long and hard producing promotional pamphlets, letters, and maps. A few months after being granted a vast tract of land, Penn wrote of his elevated purpose and his pure motives: "I eyed the Lord in obtaining it" and "owe it to his hand and power…to keep it." Penn intended to "serve his truth and people…that an example may be set up to the nations: there may be room there [in America] though not here [in Europe] for such an holy experiment."[5] He never explained exactly what he meant by that. And because Penn left his elegant vision for the city articulated, if still somewhat ambiguous, it has been up to the citizens of Philadelphia to decide if they were living this dream—or merely occupying its space. Over the centuries, no subsequent descriptions or depictions of Philadelphia could be untethered from this terse, appealing legacy.

Architect Benjamin Henry Latrobe had this legacy in mind when he urged

Philadelphians to embrace white marble and use grand public buildings to confirm the message inherent in the city's DNA. "The days of Greece may be revived in the woods of America and Philadelphia become the Athens of the Western World," he said.[6] This line from 1811 is usually considered the first expression of Philadelphia as heir to the mantle of the world's most civilized metropolis. But Latrobe likely knew this concept had been around quite a bit earlier, as far back as the 1720s, when newly-arrived London poet George Webb sang the young city's praises as the inheritor of "Europe's Wealth." Webb predicted Philadelphia's continued rise would have profound results: "Europe shall mourn her ancient Fame declin'd / And Philadelphia be the Athens of Mankind."[7] The better part of a century later, Latrobe had the training, sophistication, and ambition to express this ideal in architectural forms.

In the first year of the 19th century, and the last year of Philadelphia's decade as the nation's capital, printmaker William Russell Birch included Latrobe's new, white-marble Water Works in his city views. In a subsequent edition, Birch added Latrobe's Bank of Pennsylvania, a building that simultaneously referred to the Acropolis in ancient Athens and to the rising, independent American Republic. Philadelphians optimistic or anxious (or both) about the possibilities in the new century turned again and again to the architectural language of the Greek Revival as a form of public reaffirmation. And over the next several decades, Latrobe's imitators, his students, and their students populated the city with classical-revival buildings. Whether at the Second Bank, the United States Mint, Pennsylvania Academy of the Fine Arts, the Pennsylvania Institution for the Deaf and Dumb, or scores

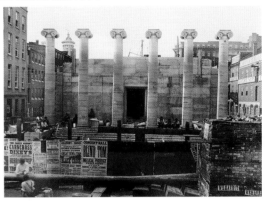

John Moran, Demolition of the Bank of Pennsylvania in 1867. Albumen Print Photograph. (The Library Company of Philadelphia.)

of churches, anyone and everyone in Philadelphia in the first half of the 19th century knew that white columns supporting entablatures and pediments signified civic virtue and greater public purpose. And if somehow citizens weren't yet aware of that fact by the late 1820s, all they had to do was glance at Cephas Grier Childs's newly published *Views of Philadelphia*. These prints spread the word far beyond the city streets: public buildings look best when they emulate Greek or Roman Temples.

As if to undermine this pretense, caricaturist Edward Williams Clay immediately worked up a set of contradictory images. Clay got behind the façades, literally, and sarcastically titled his series "Life in Philadelphia." He highlighted the rising tensions of race, gender, religion, and identity—tensions infused with consumerism, social mobility, and aspiration. He embraced the idea that Philadelphia had deep and inherent contradictions. The popularity of Clay's prints indicated broad public agreement. Word was out: the City of Brotherly Love, the Quaker City, this Athens of America, had strayed from its idealistic origins. Starting with Childs and Clay in the late 1820s, and continuing with scores of other interpreters over the next century and more, the Philadelphia

narrative would swing, according to the tellers and the times, between greatness and grief. *City Abandoned* is best considered in this context and on these terms.

Do the tumultuous decades of the 19th century, arguably the most stressed and violent in the city's history, offer a prototype for Feldman's genre? One image from that time speaks in tones similar to Feldman's. On May 14, 1838, abolitionist reformers opened and dedicated a brand-new "Temple of Free Discussion"— Pennsylvania Hall. Over the next three days, a mob outside the hall swelled in number, attacked, and, on May 17, burned the building down. Firefighters were either prevented from putting the fire out or sympathized with the rioters. For the next several years, the charred ruins of Pennsylvania Hall stood on 6th Street just south of Race as an eloquent expression of dissension and failure in the City of Brotherly Love. John. A. Woodside Jr. drew and Reuben S. Gilbert engraved an image of the hulking, empty shell that presented a stark, visual commentary on hate, violence, and shame. Their wood engraving projected a powerful message that advanced the undaunted abolitionists' cause.

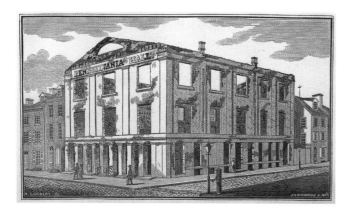

John A. Woodside Jr. and Reuben S. Gilbert, The Ruins of Pennsylvania Hall, wood engraving, 1838. (The Library Company of Philadelphia.)

At the heart of this image (as is also the case with many of Feldman's photographs), there's an activist's agenda.[8] At the height of the mobbing of Pennsylvania Hall, one of the Quaker abolitionist activists, poet John Greenleaf Whittier, disguised himself as a rioter, plunged into the chaos, and salvaged what papers he could before the blaze consumed everything. Not long after, a friend presented him with a walking stick made of wood salvaged from the ruins. Whittier's poem "The Relic" speaks, in the style of the day, to the shocking power of the place:[9]

That temple now in ruin lies!
The fire-stain on its shattered wall,
And open to the changing skies
Its black and roofless hall,
It stands before a nation's sight,
A gravestone over buried Right!

But from that ruin, as of old,
The fire-scorched stones themselves are crying,
And from their ashes white and cold
Its timbers are replying!
A voice which slavery cannot kill
Speaks from the crumbling arches still!

Artists knew that images of crumbling arches and tumbling columns—especially well-known buildings—evoked strong feelings. Only a year before the Pennsylvania Hall incident, William Breton captured the real-time demolition of Philadelphia's first courthouse. And a few years before that, Edward Williams Clay, by then a political cartoonist working in New York, interpreted President Andrew Jackson's removal of federal deposits from the Bank of the United States in Philadelphia by depicting the collapse of William Strickland's Greek Revival façade. "The Downfall of Mother Bank" might have been only a metaphor, and the building remained unscathed, but this disturbing image quickly became embedded in American popular culture. When Charles Dickens visited Philadelphia in 1842 and roomed across from this "handsome building of white marble," he noted its emptiness and its "mournful, ghost-like aspect." Dickens observed that this "Great Catacomb of investment . . . had cast . . . a gloom on Philadelphia, under the depressing effect of which it yet laboured."[10]

George Lippard managed to survive on the streets of Philadelphia during the economic depression in the late 1830s. He knew the city's contradictions from experience, and in the early 1840s wrote an ironically titled novel, *The Quaker City*, in which the city's idealistic intentions give way to evil forces within. Lippard's best-selling "revelations of the secret life of Philadelphia" elaborated "crimes that never came to trial, murders that have never been divulged." What made *The Quaker City* so powerful was that Lippard constructed it around the lives of real people and places. In a culminating scene set in the far distant future of 1950, Lippard's evil, one-eyed pimp known as the Devil-Bug dreams that a ghost takes him on a tour of the city's most symbolic building, Independence Hall:[11]

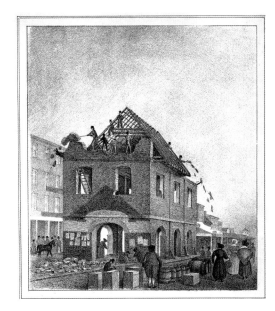

William L. Breton, "S. W. view of the old court house in Market Street, Philadelphia at the time of its being taken down 7th April 1837." Lithograph. (The Library Company of Philadelphia)

> Wandering slowly onward, he was wrapt in wonder at the magnificence which broke upon his vision, when suddenly a massive edifice rose before him, with long rows of marble columns and a massive dome breaking into the blue of the sky far overhead. Besides this gorgeous structure, which appeared to be in progress of erection . . . arose a small and unpretending structure of brick, only two stories high, with its plain old-fashioned steeple rising but half-way to the summit of the marble palace. This small and unpretending structure was in ruins, the roof torn from the steeple, the windows were concealed by rough boards, and from one corner, the bricks had been thrown down.
>
> Devil-Bug, when he beheld this structure in ruins, while the marble palace by its side arose in such grandeur up on the clear blue sky, smiled to himself and clapped his hands boisterously together.

"This," he cried, pointing to the edifice, "this should be the old State House and I must be in the Quaker City!"

"It is the old State House," whispered the ghostly form...Yes, it is old Independence Hall! The lordlings of the Quaker City have sold their father's bones for gold, they have robbed the widow and plundered the orphan, blasphemed the name of God by their pollution of his faith and church, they have turned the sweat and blood of the poor into bricks and mortar, and now as the last act of their crime, they tear down Independence Hall and raise a royal palace on its ruins!"

..."Liberty has long fled from the Quaker City, in reality has now vanished in its very name. The spirit of the old Republic is dethroned, and they build a royal mansion over the ruins of Independence Hall!"

By 1842, the year of Lippard's apocalyptic vision, Philadelphia's grandiose, capitalist aristocracy had finally overwhelmed the city's founding legacy. They had "cheated the poor out of their earnings, wrung the sweat from the brow of the mechanic and turned it into gold, traded away the bones of their fathers, sold Independence Square for building lots..." In *The Quaker City*, Lippard declared Philadelphia dead. And as Philadelphia went, so went America. "There is no America now. In yonder ruined Hall America was born, she grew to vigorous youth, and bade fair to live to a good old age, but—alas! alas! She was massacred by her pretend friends. Priest-craft, and Slave-Craft, and Traitor-craft were her murderers."

In the 1790s, Lippard's literary hero, Philadelphia novelist Charles Brockden Brown, had declared that America need not depend upon the traditional European devices of "castles and chimeras" when "incidents of Indian hostility, and the perils of the western wilderness" were so available and potent.[12] In a dedication at the front of his novel, Lippard acknowledged Brown's influence; inside *The Quaker City*, he repositioned the American Gothic literary imagination from the countryside to the city. Lippard's vision of despair played out in here-and-now Philadelphia, arguably the most American of cities. And his depraved vision of Independence Hall, the most civic and symbolic of American buildings, was central to the nightmare. The Quaker City, the City of Brotherly Love, had strayed from its idealistic intentions. No matter, Philadelphia would forever remain accountable for them.

In Vincent Feldman's *City Abandoned* we find relationships with the literary and graphic traditions predating photography, and we also find threads connecting to Philadelphia's early photographers. Frederick Gutekunst, Robert Newell, William Rau, and others of the more commercially-inclined 19th-century photographers celebrated the spirit of industry and commerce and seemed almost incapable, except begrudgingly, of indulging in the past. As the city grew and changed at a dizzying pace in the second half of the 19th century, however, other photographers did craft an antiquarian

aesthetic. James E. McClees, Frederick DeBourg Richards, John Moran, John Coates Brown, as well as others, explored the increasingly lamented, fast-fading past. It is revealing to examine Feldman's work alongside theirs.

In 1856, when fire devastated much of the block across from Independence Hall, James E. McClees captured the smoking ruins and was sure to frame the Hall's bell tower in the distance. This image is very much about time and place, but its success very much relies on the deep tones and abstract composition of a masterful salt print. Did McClees know of Lippard's vision? He must have: more copies of *The Quaker City* had sold than any previously published novel.

With the 1860s came the ability to make clearer, sharper, and more richly toned albumen prints. John Moran insisted on taking full advantage of these capabilities then, just as Feldman would make the most of printing techniques a

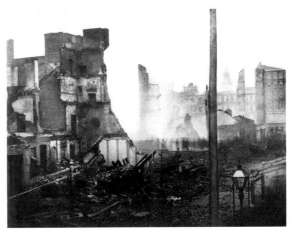

James E. McClees, "View of the ruins caused by the great fire northeast corner of Sixth and Market St. which began on the night of Wednesday, April 30, 1856 – From the northwest." Salt print photograph. (The Library Company of Philadelphia.)

century and a quarter later. Moran's large-format, wet-plate negatives enabled him to produce albumen prints of Philadelphia with needle-sharp detail. Moran's always-exquisite compositions presented building not as scenes in a bustling industrial city but as respectful theatrical sets from a deep and respected (if not actually remembered) past. Moran's *Bank of Pennsylvania* from 1867 (see image on p. xvii) lovingly isolates its subject, capturing remnants of the façade just as the building was coming down. Moran's image seems to be an overt reference to ruins in ancient Athens, except in this case there would soon be no ruins left. The columns from Latrobe's defunct bank building would be recycled as monuments at Civil War cemeteries.

When Moran couldn't approach his subjects head on, he (like Feldman) would represent buildings in the most thoughtful of compositions. Just days before its demolition, Moran depicted the *Slate Roof House, 2nd above Walnut*, where William Penn had lived while in Philadelphia. His image is a funereal study of a meaningful but doomed landmark. Similarly, Moran knew his *House in Mickle's Court, 1869* would soon meet its demise. A powerful image is a faint substitute for preservation, but there was value in *dignified* images. On several levels, Moran and Feldman share similar motives: choice of subject, compositional respect, detail, and print quality. Their work also shares an abiding respect for Philadelphia's past and a profound commitment to, as Moran put it, the photographer's "power to see the beautiful."[13]

As we've seen, Feldman's images continue traditions that date back to the 19th century, and they have a mindset that goes back even further. Ruins hold mystery for Feldman, who describes holding his print of the (now demolished) Ile Ife Museum at 7th and Dauphin Streets and recalling the first scene in Act 5 of Shakespeare's *Hamlet*. "It's like holding Yorick's skull," he says. Feldman demands that we, too, ask penetrating questions, but his photographs resist providing easy answers.

On occasion, Feldman's images help us consider *possible* answers. They encourage us to step away from the world of photography and into the world of urban policy and design and the challenges Philadelphia faced in the second half of the 20th century, and faces today. "A city is measured by the character of its institutions," said Louis I. Kahn in 1971. "Today, these institutions are on trial...because they have lost the inspirations of their beginning."[14] Feldman's images recall those inspirations and offer us the opportunity to reflect on the city in the poetic terms Kahn puts forth: "When one thinks of simple beginnings which inspired our present institutions, it is evident that some drastic changes must be made which will inspire the re-creation of the meaning, *city*, as primarily an assembly of those places vested with the care to uphold the sense of a way of life."

Vincent Feldman challenges us to see, but also to step back as we experience *City Abandoned*, to "sense the loss" and "sense the value." He wants these images to "ignite the imagination." Feldman urges us to consider his photographs in the context of the present and in terms of Philadelphia's narrative traditions. He urges us to reflect on all of this and "allow ourselves to enter a higher consciousness" about the city, its past and future. And why would Philadelphians accept a challenge any less daunting and any less necessary?

NOTES

[1] In a blog post of August 1, 2009, at *Vice Magazine*, Morton quotes Detroit photographer and blogger James Griffioen using the term "ruin porn," apparently for the first time. Referring to a rush of out-of-town journalists documenting Detroit's decline, Griffioen said, "The photographers are the worst. Basically the only thing they're interested in shooting is ruin porn." http://www.vice.com/read/something-something-something-detroit-994-v16n8. In a segment titled "Ruin Porn" aired September 25, 2009, Bob Garfield interviewed Morton for NPR's *On the Media*. Morton describes this approach as misleading but acknowledges the appeal: "I think people just like a good ruin. I mean, setting aside like any kind of like deep philosophical implications of it, it's just people like a good smashed-up thing. I know I do," http://www.onthemedia.org/2009/sep/25/ruin-porn/transcript/.

[2] "Detroitism," *Guernica*, January 15, 2011, http://www.guernicamag.com/features/leary_1_15_11/

[3] "The Consequences of Ruin Porn," *Feministe* (blog), September 15, 2011, http://www.feministe.us/blog/archives/2011/09/15/the-consequences-of-ruin-porn/.

[4] Vincent Feldman, interview by Kenneth Finkel, December 20, 2012.

[5] See Robert Proud, *The History of Pennsylvania, in North America, from the Original Institution and Settlement of that Province, Under the First Proprietor and Governor, William Penn, in 1681, Till After the Year 1742*, (Philadelphia: Zachariah Poulson, Jr., 1797), 1:169.

xxiii

6 See Gary B. Nash, *First City: Philadelphia and the Forging of Historical Memory* (Philadelphia: Univ. of Pennsylvania Press, 2006), 140–41.

7 See George Webb's poem "A Memorial to William Penn," published in *The Genuine Leeds Almanack for the Year of Christian Account, 1730* (Philadelphia: Printed by D. Harry, 1729), and David S. Shields, "The Wits and Poets of Pennsylvania: New Light on the Rise of Belles Lettres in Provincial Pennsylvania, 1720–1740," *The Pennsylvania Magazine of History and Biography* 109, no. 2 (April 1985): 126–127.

8 Feldman sees his photographs as "a way to reflect on loss and failure" but also "as a call to action." He believes using the past to show "the direction of failure" can avert a "lack of consciousness." Vincent Feldman, interview by Kenneth Finkel, December 20, 2012.

9 "The Relic: Written on receiving a cane wrought from a fragment of the wood-work of Pennsylvania Hall which the fire had spared," 1839.

10 Charles Dickens, *American Notes for General Circulation* (London: Chapman and Hall, 1842), 1:235.

11 See George Lippard, *Quaker City, or, The Monks of Monk Hall*, ed. David S. Reynolds (Amherst: Univ. of Massachusetts Press, 1995), 372, 373, 374, 388.

12 Brown included this comment in 1799 in his prefatory note "To The Public." See Charles Brockden Brown, *Edgar Huntly, or, Memoirs of a Sleep-Walker; with Related Texts*, eds. Philip Barnard and Stephen Shapiro, (Indianapolis: Hackett, 2006), 4.

13 See John Moran, "Thoughts on Art, Nature and Photography," in *The Philadelphia Photographer*, (June 1875): 179. As a pioneer art photographer from the early 1860s to the mid-1870s, John Moran explored the aesthetic possibilities of his medium in practice and theory with Philadelphia streetscapes and landscapes as his subjects. Also see his other articles in *The Philadelphia Photographer*: "The Relation of Photography to the Fine Arts," (March, 1865): 33, and "Reflections on Art," (October 1875): 294. In 1870, The Library Company of Philadelphia purchased from him a unique album of 77 albumen prints entitled "A Collection of Photographic Views in Philadelphia and its vicinity." Titles and images can be seen at "Places in Time: Historical Documentation of Place in Greater Philadelphia: John Moran Photograph Collection at the Library Company of Philadelphia," http://www.brynmawr.edu/iconog/mrn/mlist.html.

14 "The Room, the Street and the Human Agreement" (1971), in *Louis Kahn: Essential Texts*, ed. Robert Twombly (New York: W.W. Norton, 2003), 256.

Ridge Avenue Farmers' Market, 1995

Introduction

As a child, I enjoyed paging through my father's copy of Edward Gibbon's *The History of the Decline and Fall of the Roman Empire*. The volumes contained many plates from Giovanni Battista Piranesi's 18th-century views of Rome's ruins. Those images still have a profound impact on my imagination and intellect. The excitement of unearthing mysteries from an obscured past and the spirit of discovery flow from them.

Later, in college, I had similar impressions examining Eugene Atget's photographs of the remains of the *Ancien Regime* and Matthew Brady's depictions of southern cities annihilated during the American Civil War. Stones speak, and their stories can be captivating. Contemplating ruins powerfully affects one's thoughts in both objective and subjective ways. These effects can impress the romantic *and* the rationalist, raising a broad spectrum of questions that make ruins a tremendously compelling subject for art.

In 1993, when I first cautiously approached the intimidating, abandoned Ridgway Library, the first building I photographed in this series, I felt I was trespassing on history. For years I had gone past this landmark—on Broad Street, several blocks south of City Hall—which was surrounded by a weedy lawn and crippled ironwork, but like so many passersby, I gave it only a cursory glance. Habituation to decayed sites, like the Ridgway Library, psychologically masks them from a keener perception. But as I entered the library's grounds through one of its fallen gates, I seemed to have stumbled on the good fortune of glimpsing a world that paralleled the ones Atget, Piranesi, and Brady portrayed so intricately.

I had an awakening of sorts, since I soon discovered this neoclassical ghost on Broad Street was no anomaly. The city was rich with forgotten places, surprisingly profound in their historical accounts. To be in their presence can move us to the depths of our consciousness. The awe these moments inspired drew me again and again. I repeatedly walked the paths that once wound through the grounds of the United States Naval Asylum, a twenty-acre campus hidden in plain sight in a corner of Center City. For 150 years before being abandoned in 1976, it had a distinguished history, which few neighbors could recall or seemed to care about.

A year after my first visit to Ridgway Library, I happened upon Lynnewood Hall in Elkins Park, a once-opulent 110-room mansion and museum that formerly housed the greatest art collection in the Philadelphia region. Its formal gardens were strewn with downed trees and branches, its garden statuary covered in vines.

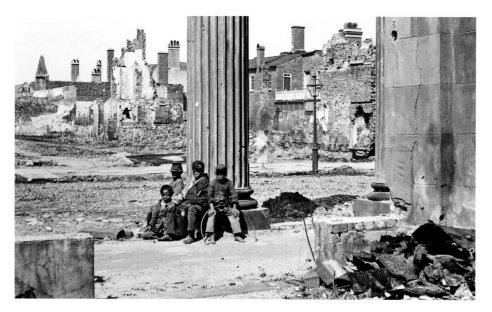

*George N. Barnard,
Charlestown, S.C. View
of ruined buildings
through porch of the
Circular Church, 1865,
(detail from glass
stereograph)*

Inside the darkened hulk, stripped of many of its appointments, a few Korean seminary students sat huddled around a kerosene heater, reading bibles. Could our apparently innate American optimism, so clearly expressed in the textures and designs of Philadelphia's early modern landscape, cloud our perceptions and inhibit our ability to fathom these signs of loss around us? These ghost-like buildings invite questions: What were the places originally like? Who were the people who made them? What is the nature of a society that severs itself so severely from its past?

I rarely found even a marker indicating the former importance of the buildings I was photographing. And the stories neighbors told of the building's history were sometimes very imaginative, and often inaccurate. When setting up my camera, I was often asked if I knew what "they" were going to do to the place. There was no denying the strength of the questions that these overlooked sites prompted. Often I myself did not know the origins of the place I was photographing. One remarkable moment among many I experienced in compiling these photographs occurred after I had pushed through the undergrowth to get a closer look at an old mansion that I had spotted behind trees high above Lincoln Drive. From the rusted playground in back and the adjacent 1950s-era school on its grounds, I assumed it must have once been used as a school. For some time, I knew only its name, Park Gate, which suggested something of importance. Like Lynnewood Hall, it had also housed an important art collection. Indeed, in the first half of the 20th century, Park Gate was a cultural mecca. Today, surrounded by forest, it is a ruin.

As my collection of these places grew, my photographs of them became more like portraits than landscape photography. The power of their collective questions increased. By the late 1990s, when the photographs in this collection made up a sizable portfolio, I began to organize them into groups, which I defined according to each building's original use. These groupings produced a city in miniature,

filled with empty libraries, museums, fire houses, schools, post offices, police stations, hospitals, et cetera—the major bricks and mortar institutions that make up a city. I titled my growing collection of photographs, City Abandoned. Philadelphia appeared to have a surplus of these once-valued, now empty, civic institutions.

Because there are tens of thousands of vacant and abandoned buildings in Philadelphia, I had to be very selective in choosing the ones to photograph. I focused on buildings that attracted me in either an aesthetic or conceptual way. I avoided residential buildings and concentrated on institutional ones, places in which citizens had a stake or where we were all once welcomed. Like Atget's hundred-year-old photographs of Paris, the photographs in this volume portray a society that has passed from us. However, at the time they were planned and built, the urban ideal defined America's future. Not only great engines of economic growth, cities were also intense incubators for a wealth of ideas. Their design and presence express the exhilaration and hope for enlightenment that urban life in our country once represented.

Public buildings were at the center of this life. A hundred years ago, these structures were springing up all over Philadelphia. The ennobling character of their entrances, like the one found on the Anthony Wayne Elementary School, expressed the seriousness of their public mission. When these gateways were permanently closed, and soon after were covered in the graffiti of neighborhood youth, this symbolism was turned inside out.

The Philadelphia aspiration to be a great metropolis, which developed over the course of three generations, turned into a nightmare. The most significant factor in Philadelphia's decline was its loss of manufacturing muscle. Philadelphia had been in the vanguard of the Second Industrial Revolution. The list of innovations, firsts, and leading roles in manufacturing is long—beginning with the first paper mills in American and continuing through the invention of the digital computer. Federal housing, transportation, racial policy, and local

Ridgway Library, 1993, detail

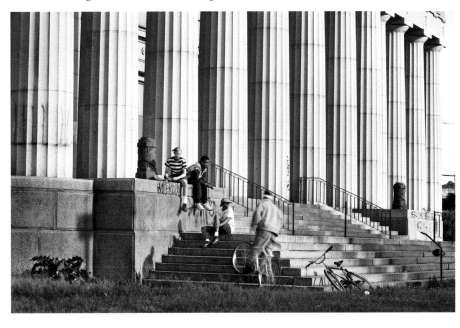

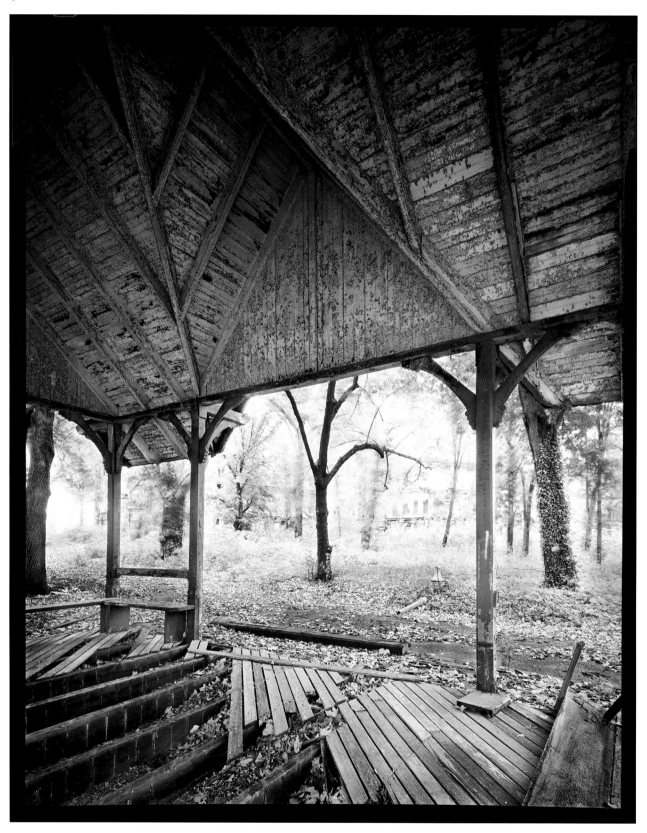

United States Naval Asylum, gazebo, 2002

tax and funding structures threw salt in these economic wounds. And there are many other contributors to the turnabout from prosperity to poverty. However one explains the decline, it leaves one with a disquieting sense of puzzlement that hints at despair: How did this decline occur, and what can be done to reverse it?

The pictures in this book portray a landscape and selected buildings left in the wake of this great retreat. The image of Germantown Hall is as good an example of this as you can find—its Greek revival facade a style introduced to the New World in 1800 in Philadelphia to demonstrate the eloquent achievements and values made manifest by our fledgling democracy. An enduring form, it was employed for the 1923 replacement of the original Germantown Hall building. The picture was taken a few years after the last city department moved out, which was followed shortly by the theft of its brass lampposts. Just days before I took my photograph, President Bill Clinton, during his President's Summit in 1997, assisted in painting over the graffiti on the door to the already vacant Mayor's Action Center.

In the past decade, Center City and its adjacent neighborhoods have experienced a surprising turnaround. Yet, beyond this area, schools continue to close, libraries and cultural repositories struggle to remain open, and more churches and homes become vacant. By inviting you to look carefully at buildings from Philadelphia's past, I hope to promote inquiry about our history *and* also to inspire thoughtful discussion about what we might do for our future.

Government

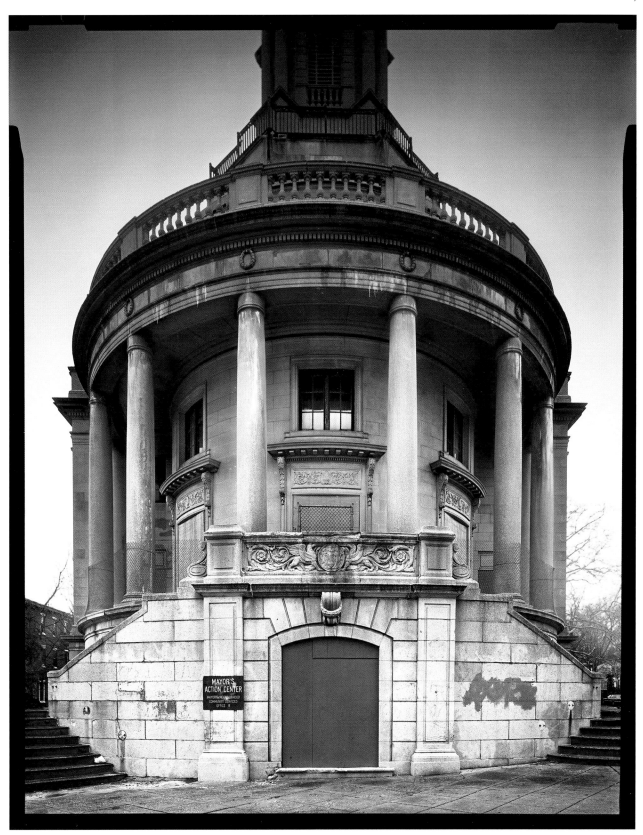

Germantown Hall, 1997

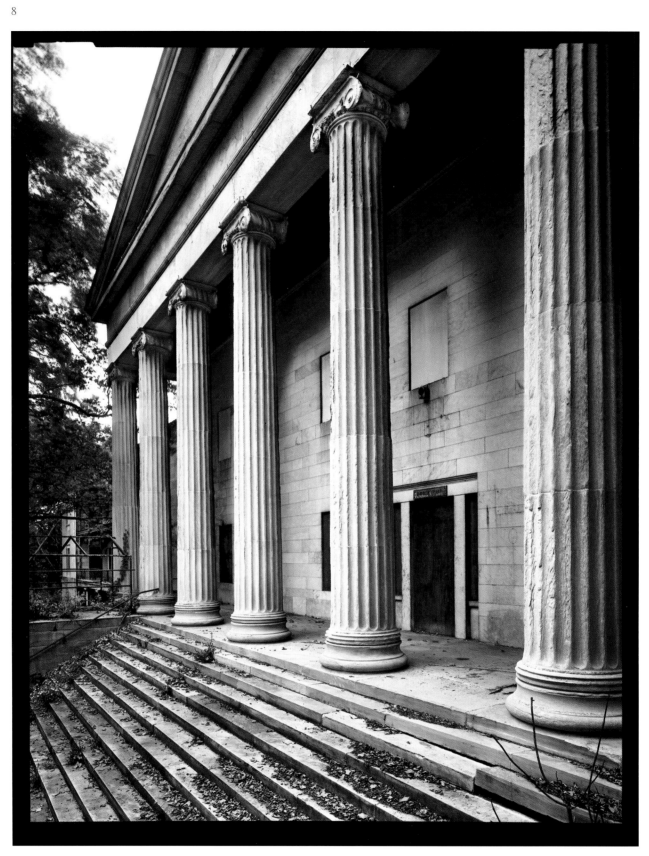

United States Naval Asylum, Biddle Hall, 1993

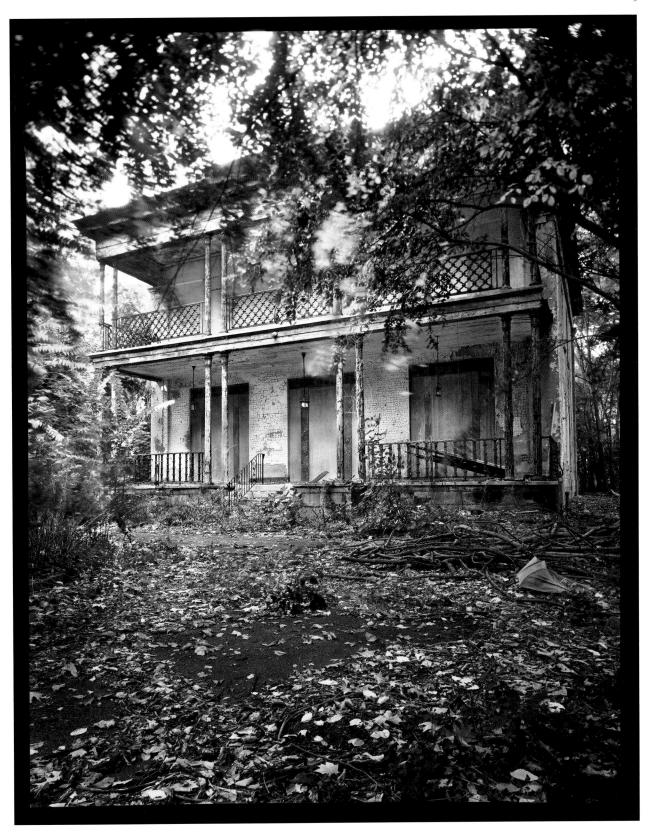

United States Naval Asylum, Governor's Residence, 1993

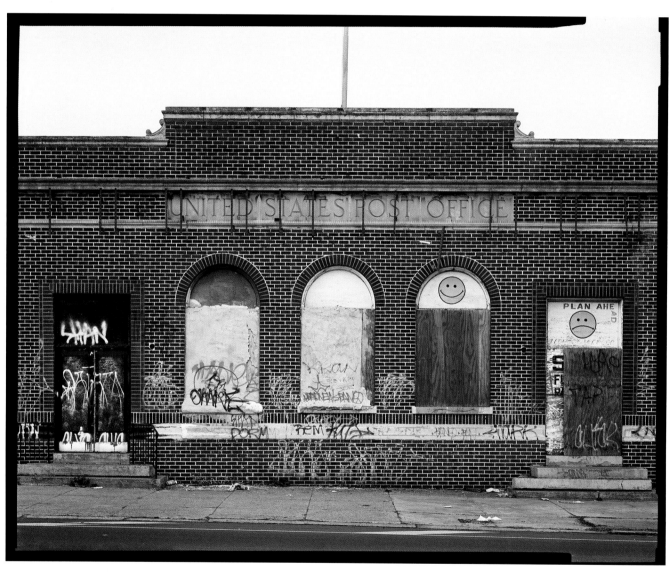

United States Post Office, 1995

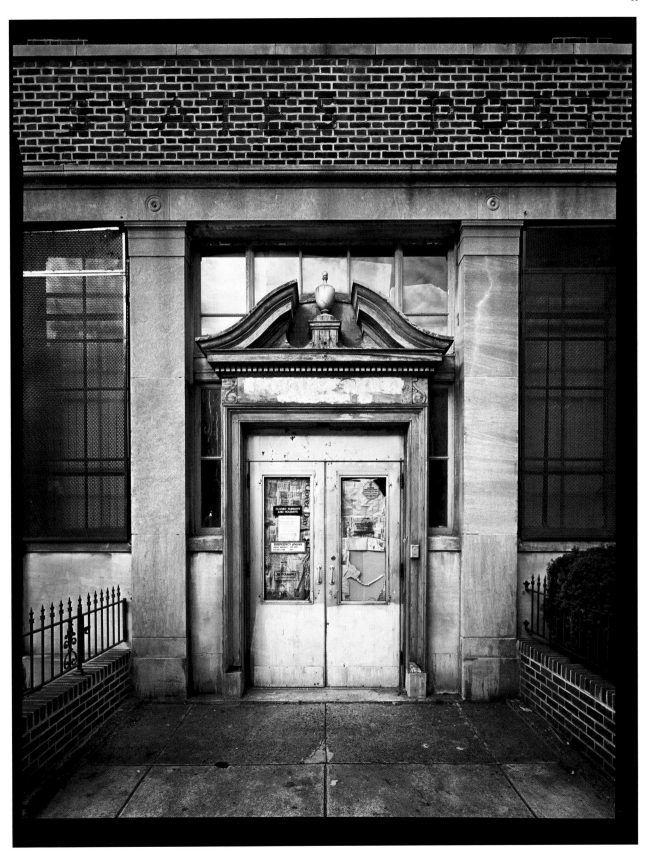

United States Post Office, 1997

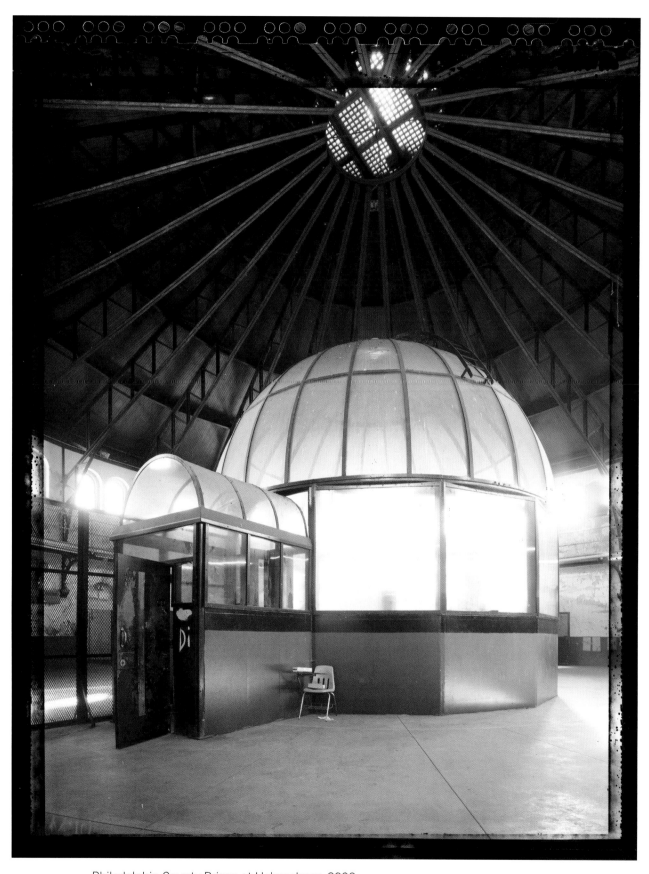

Philadelphia County Prison at Holmesburg, 2002

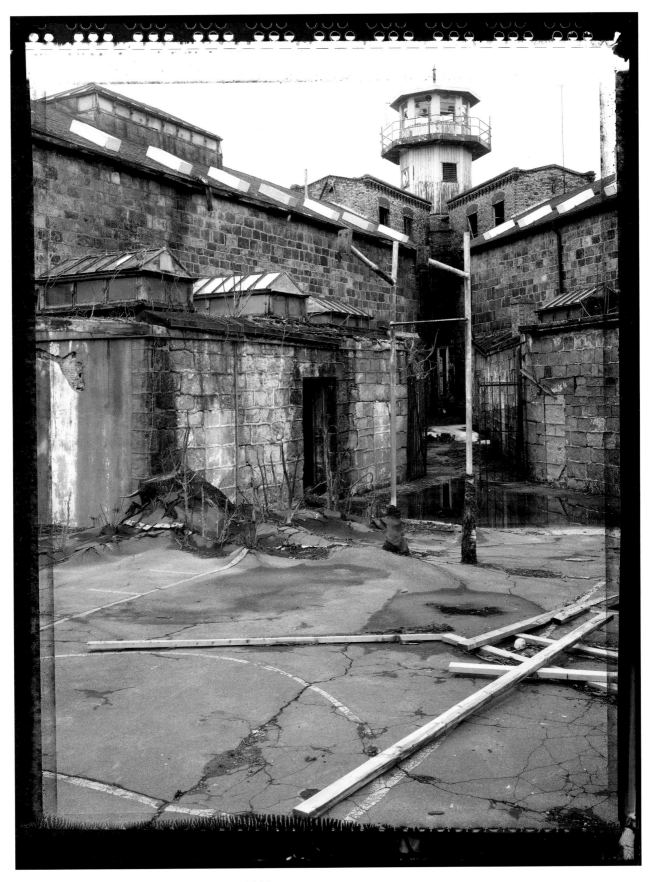

Eastern State Penitentiary, 1993

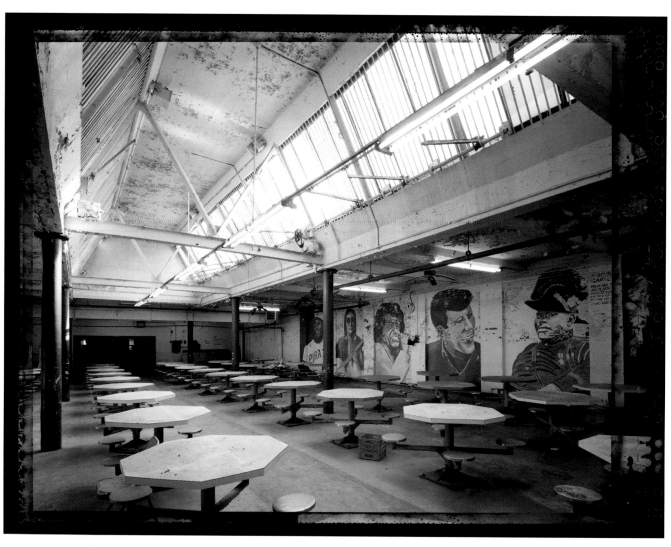

Philadelphia County Prison at Holmesburg, Cafeteria, 2002

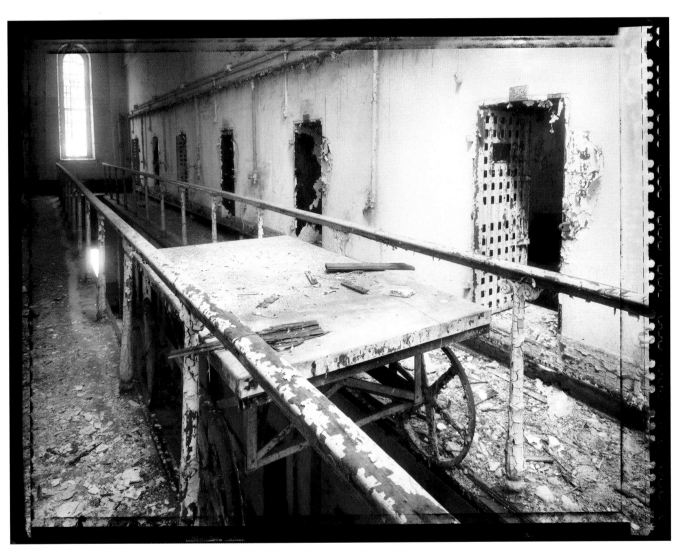

Eastern State Penitentiary, Food Cart, Cell Block Five, 1993

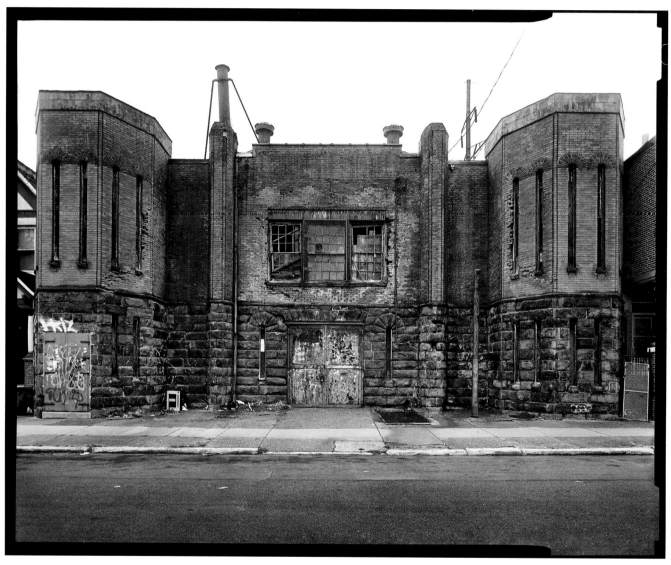

National Guard Patrol, Battery A, 1997

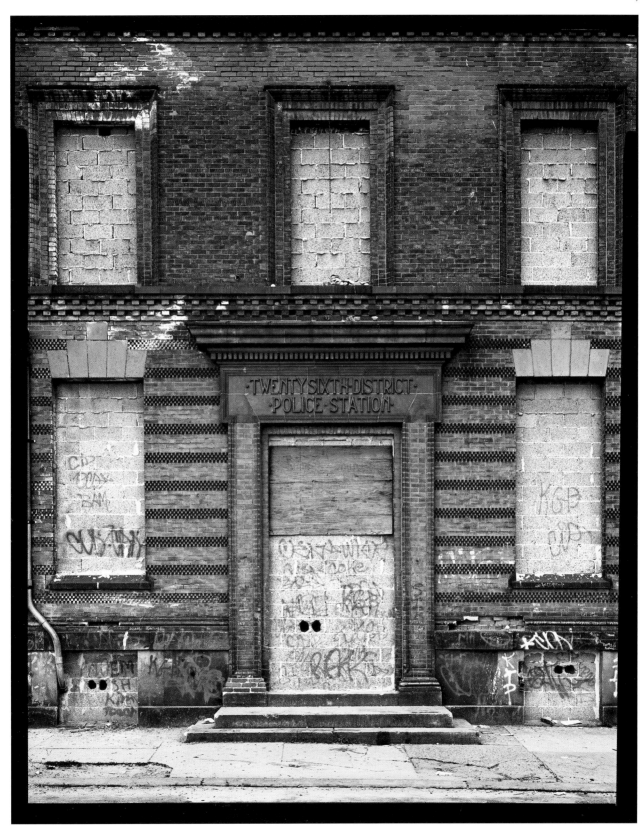

Twenty-sixth District Police Station, 1994

18

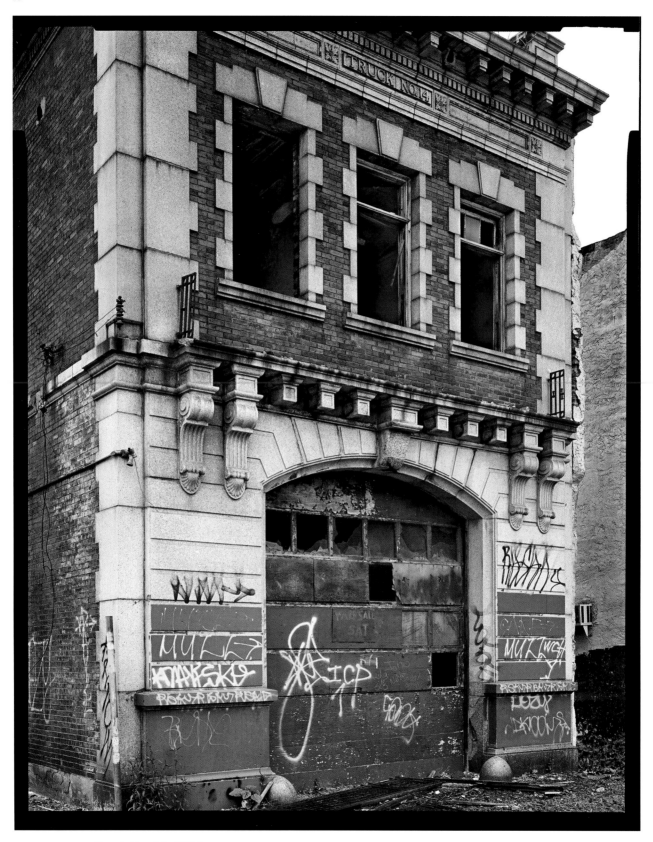

Truck No. 14, 1994

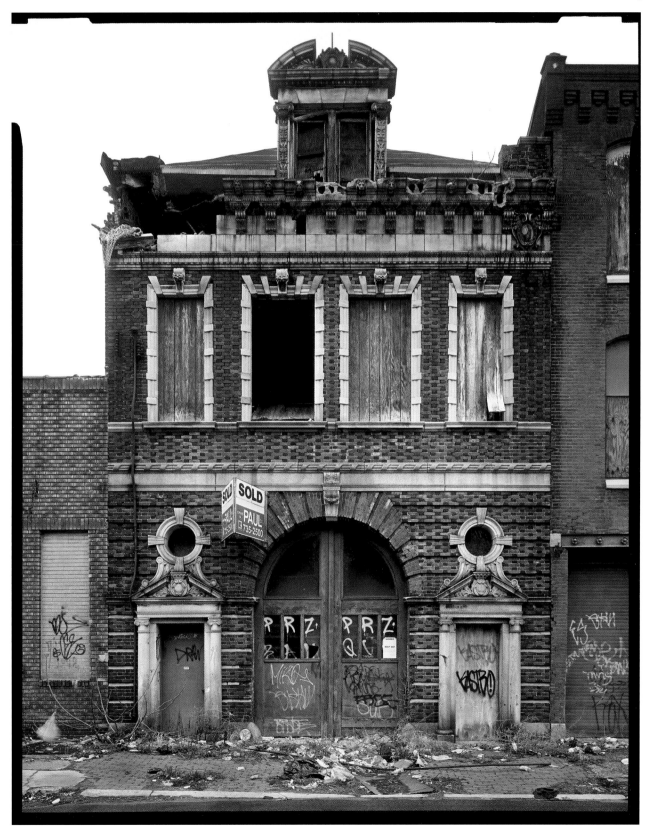

Engine Company 13, 2001

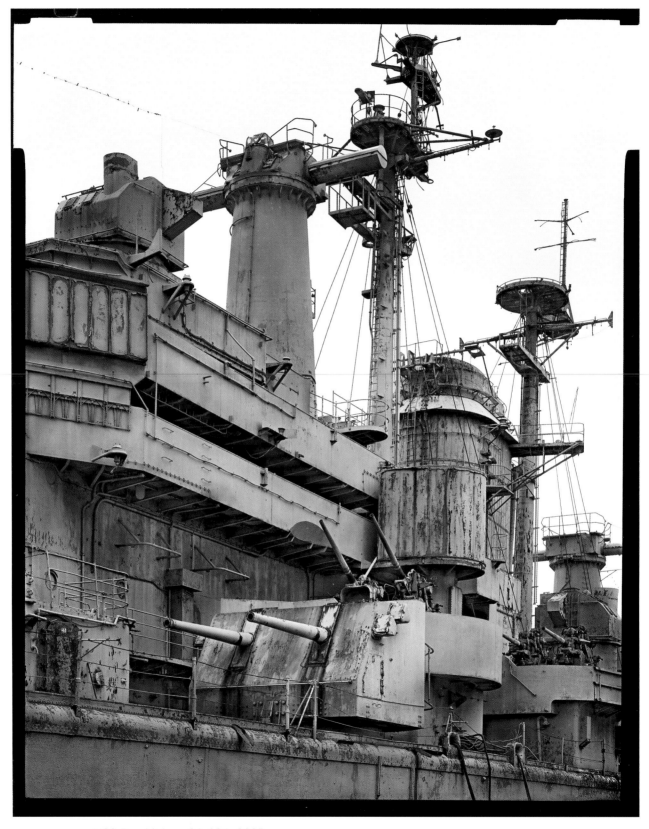

USS Des Moines CA-134, 2005

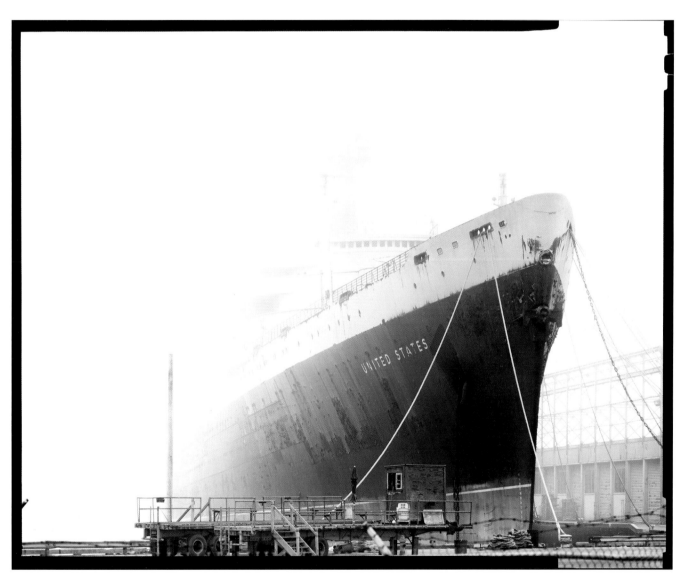

SS United States, 2006

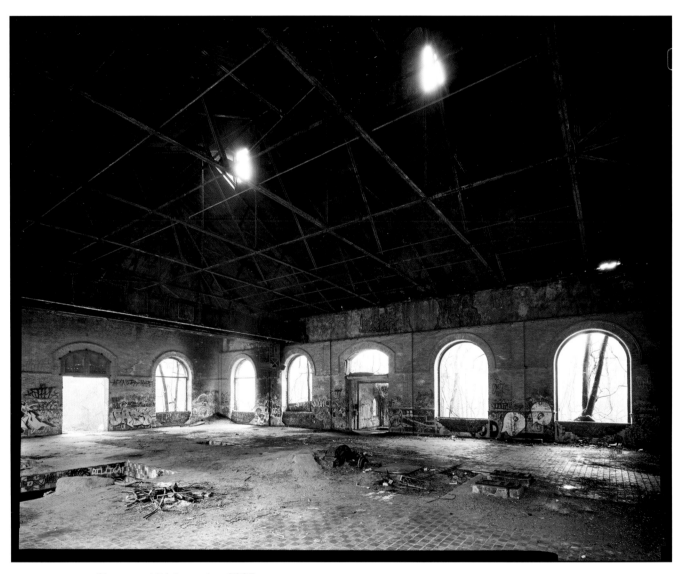

Shawmont Waterworks, 2005

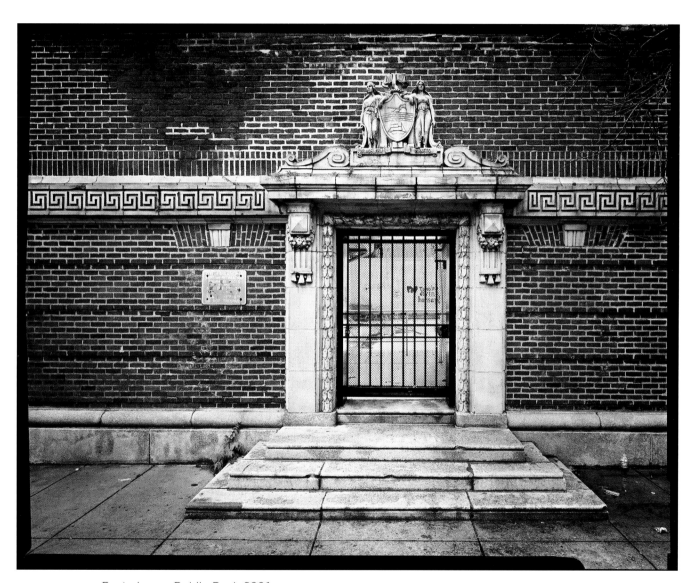

Fante-Leone Public Pool, 2001

Health and Human Services

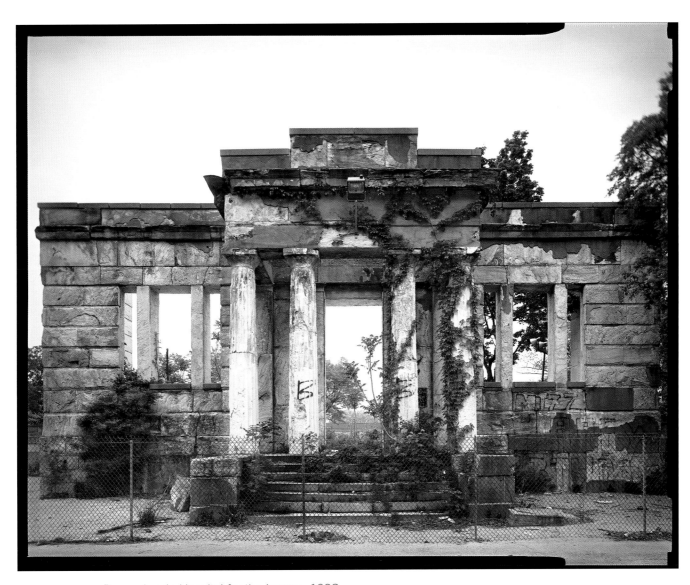

Pennsylvania Hospital for the Insane, 1998

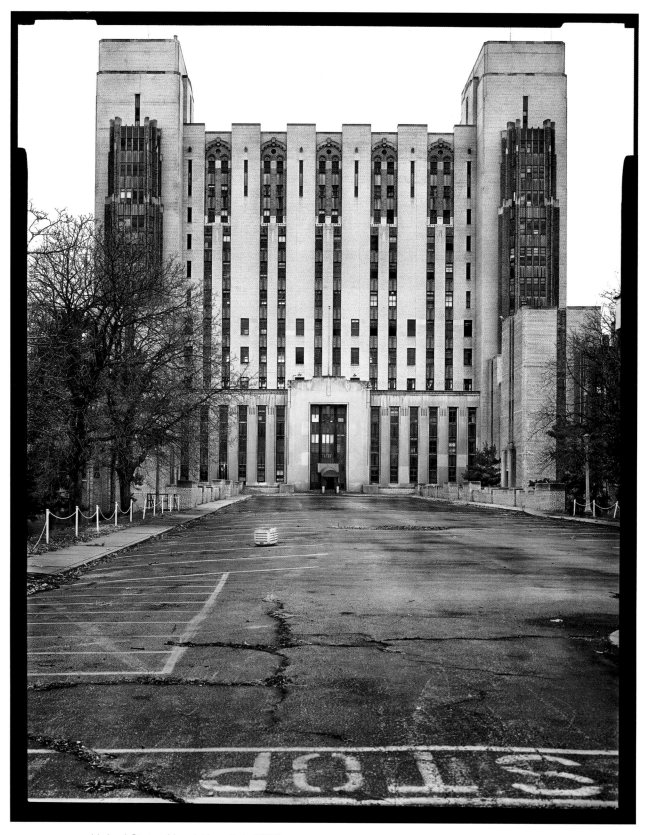

United States Naval Hospital, 1998

Nicetown - Tioga Health Center, 1998

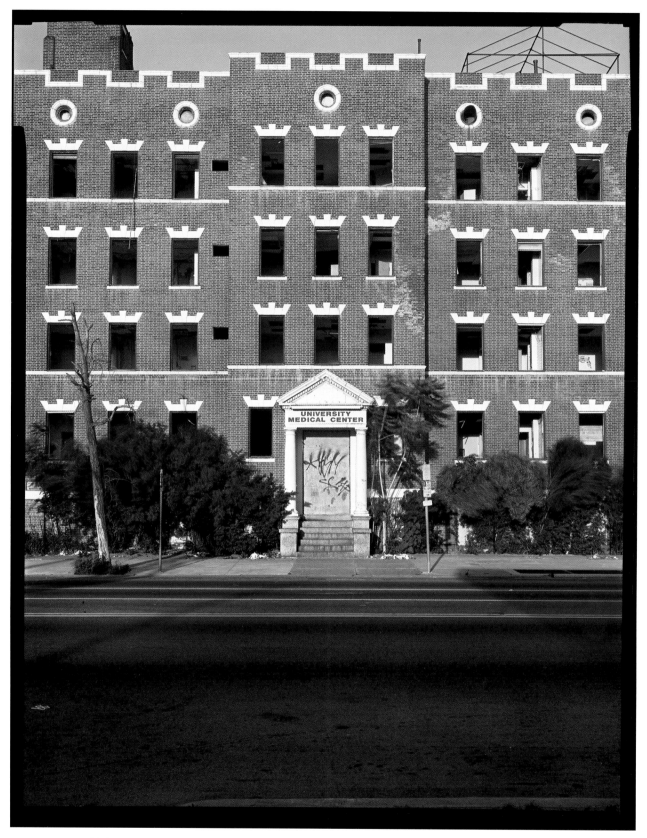

University Medical Center, 1993

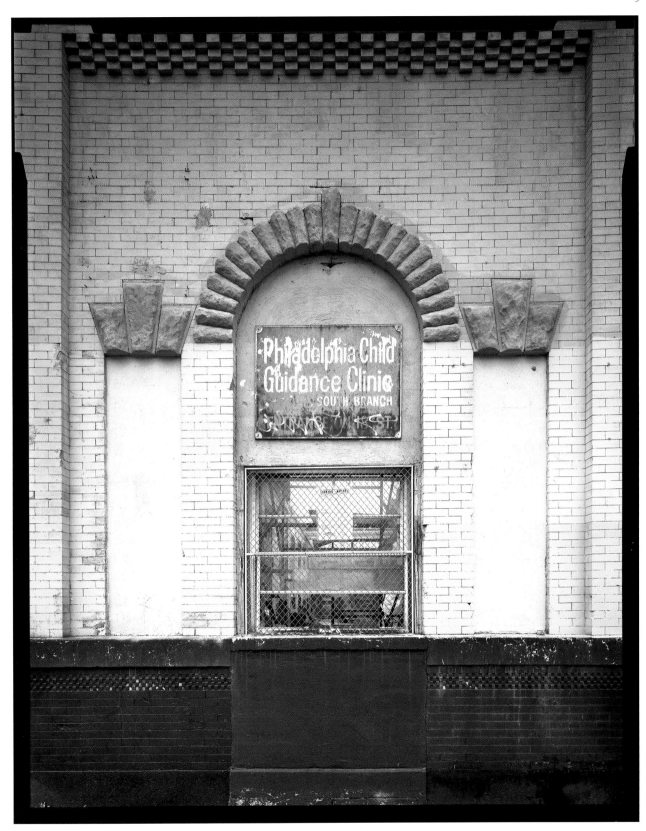

Philadelphia Child Guidance Clinic, 2005

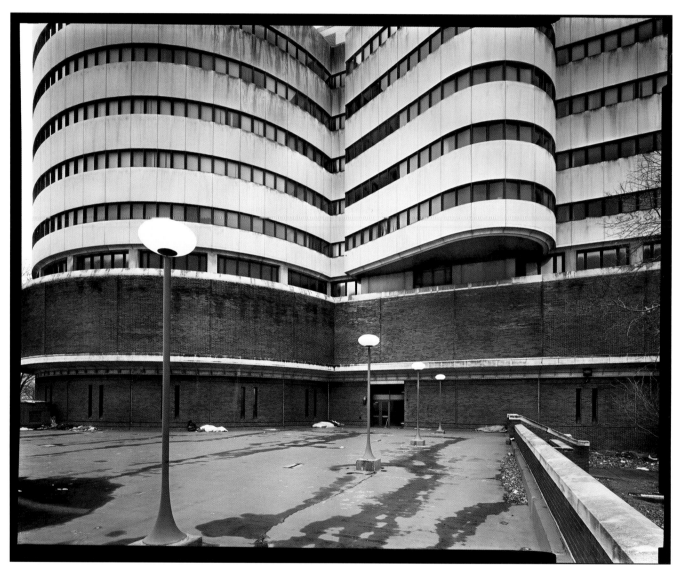

Former Metropolitan Hospital, 1997

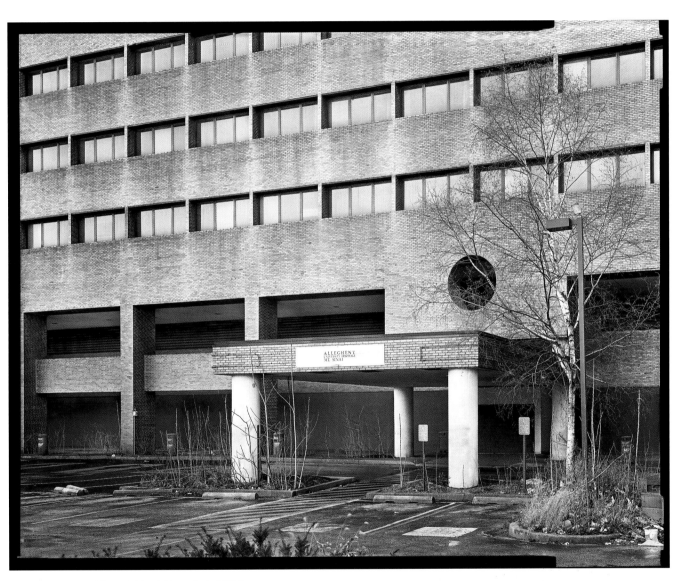

Mount Sinai Hospital, 2000

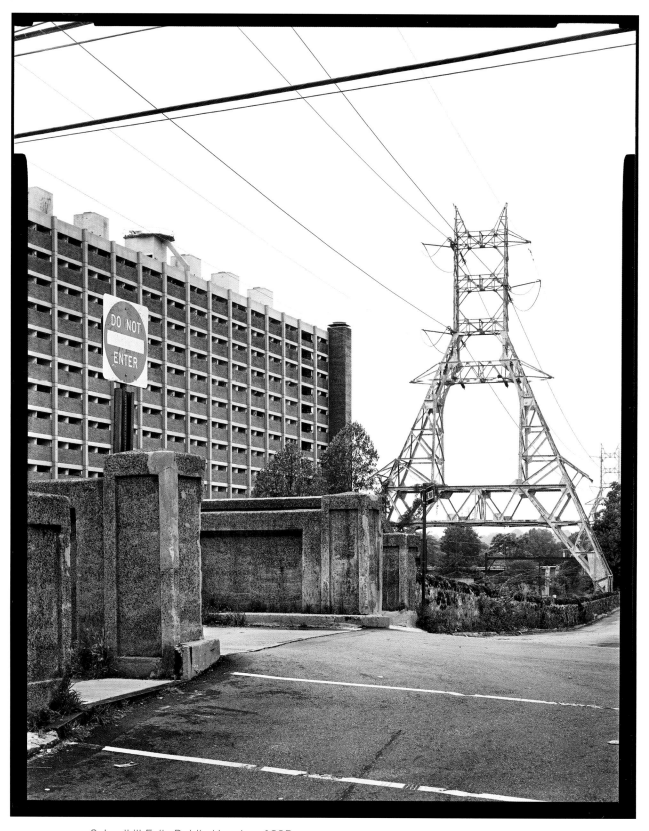

Schuylkill Falls Public Housing, 1995

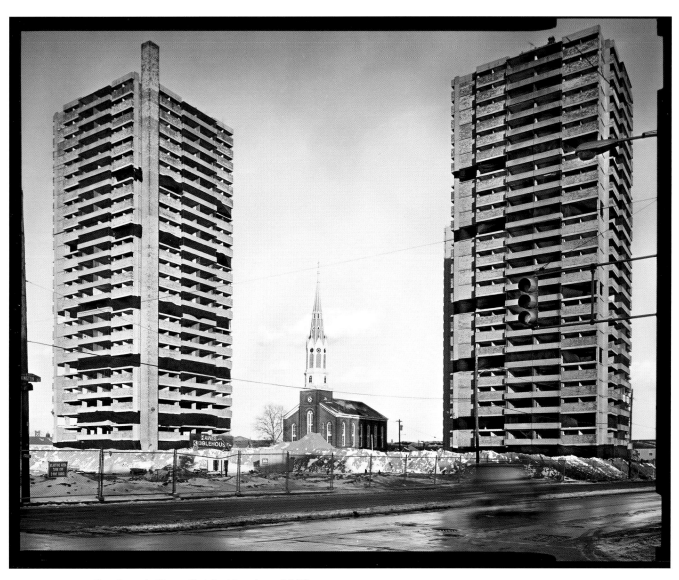

Southwark Plaza Public Housing, 2000

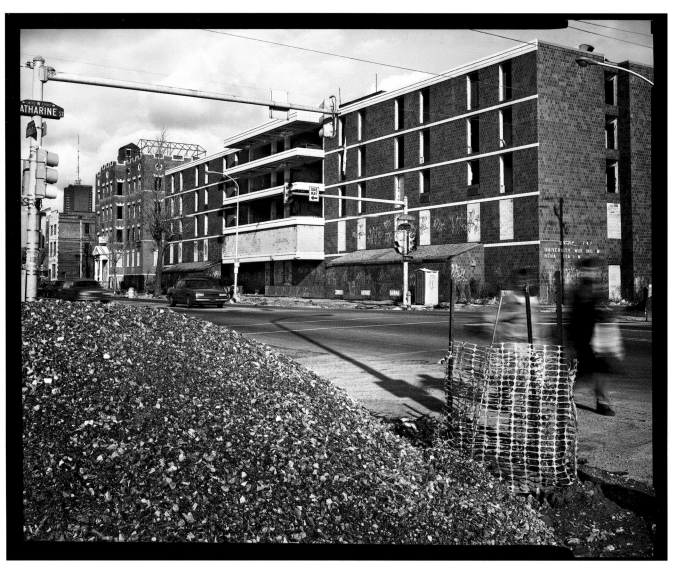

University Nursing and Rehabilitation Center, 1994

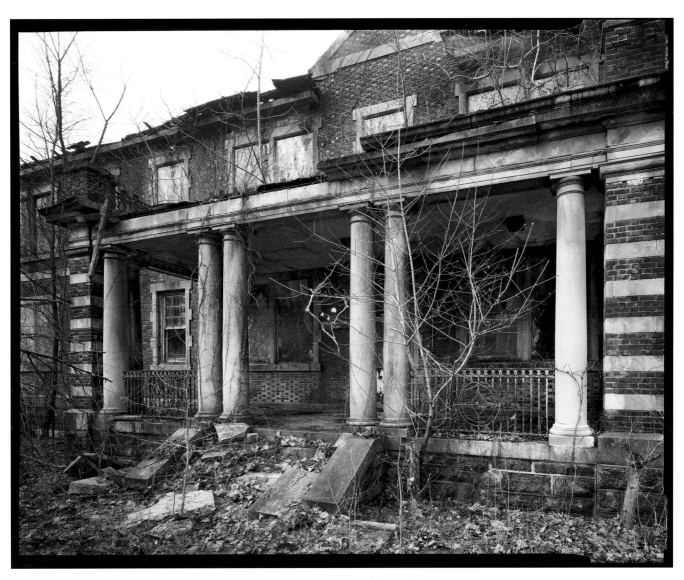

The Philadelphia State Hospital for the Insane at Byberry, 2005

Education

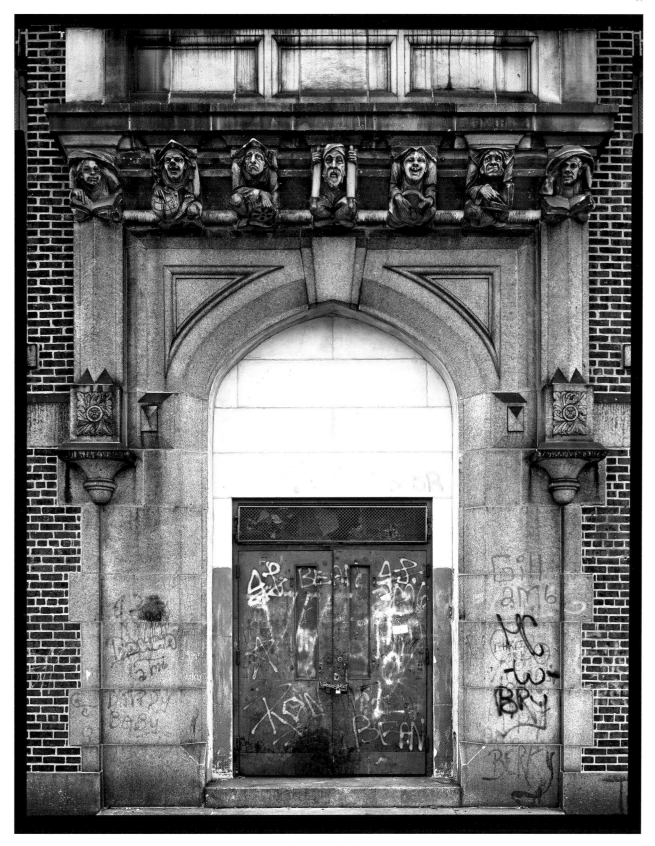

Anthony Wayne Public Elementary School, 1993

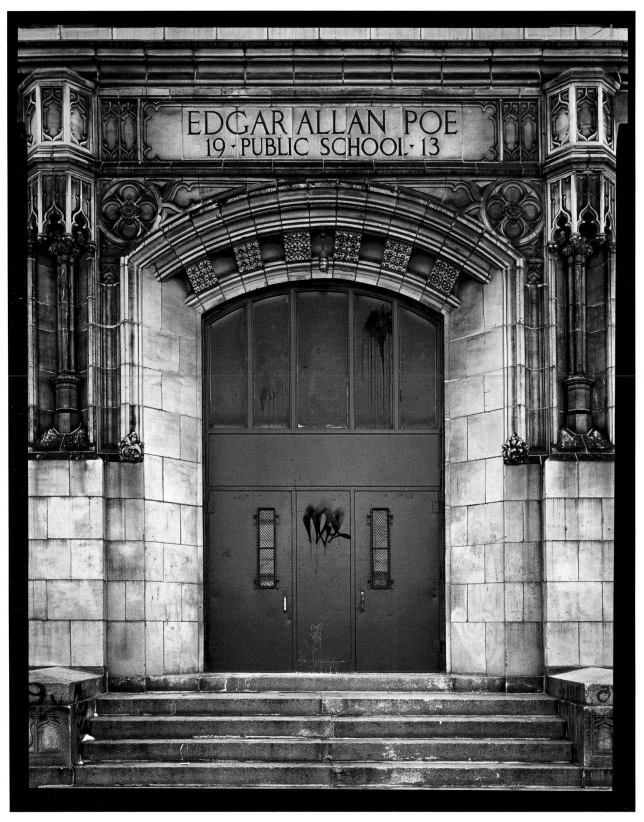

Edgar Allan Poe Public School, 1995

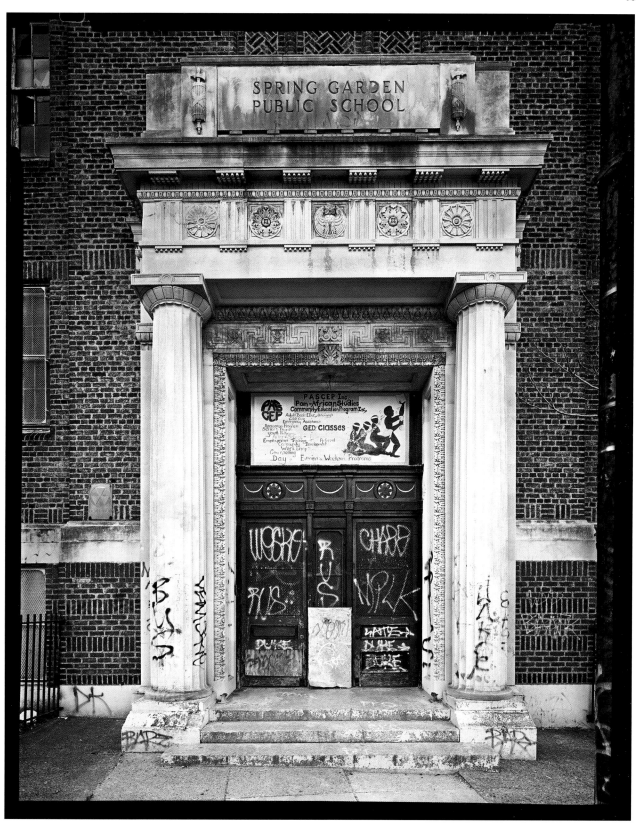

Spring Garden School Number 1, 1998

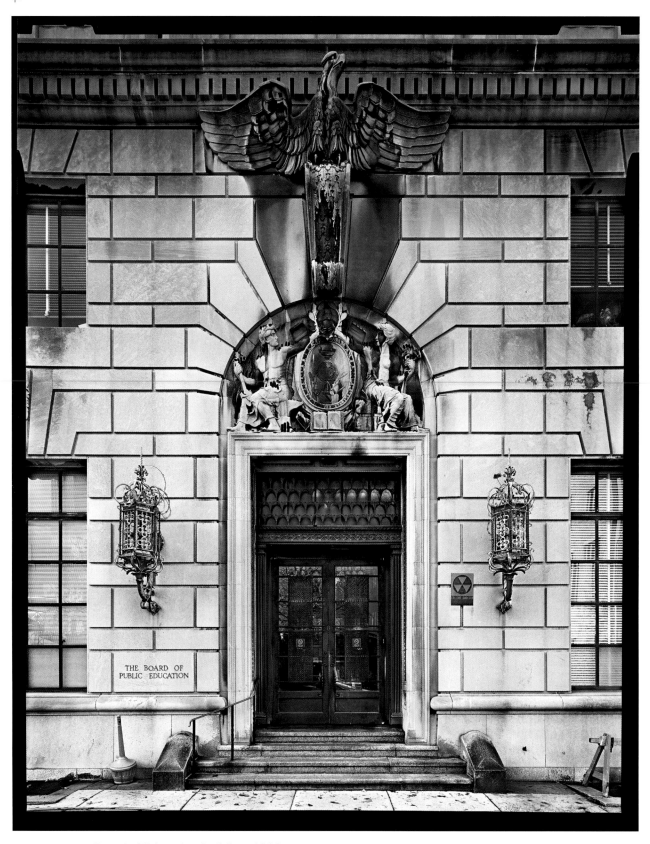

THE BOARD OF
PUBLIC EDUCATION

Board of Education Building, 1998

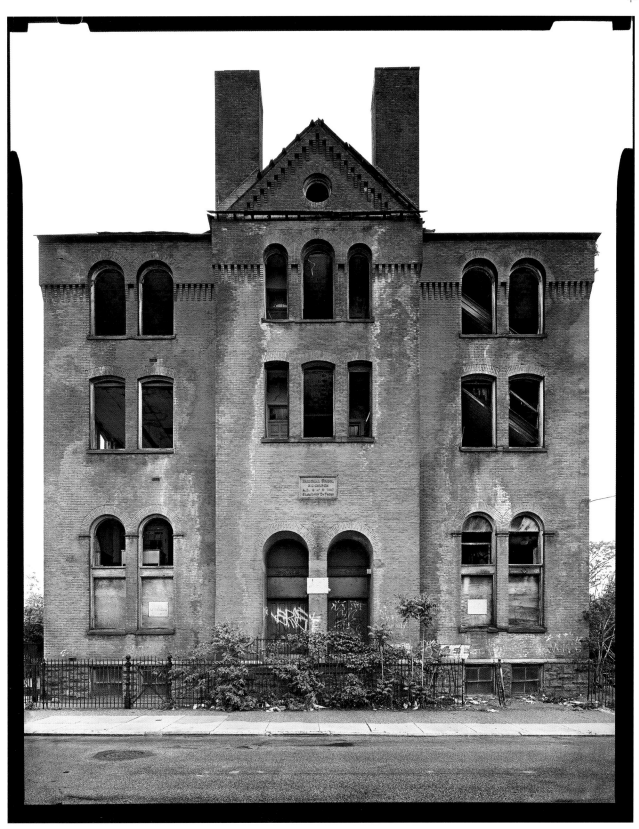

St. Anthony De Padua School, 1998

Martin Luther King Jr. Living Memorial, 1995

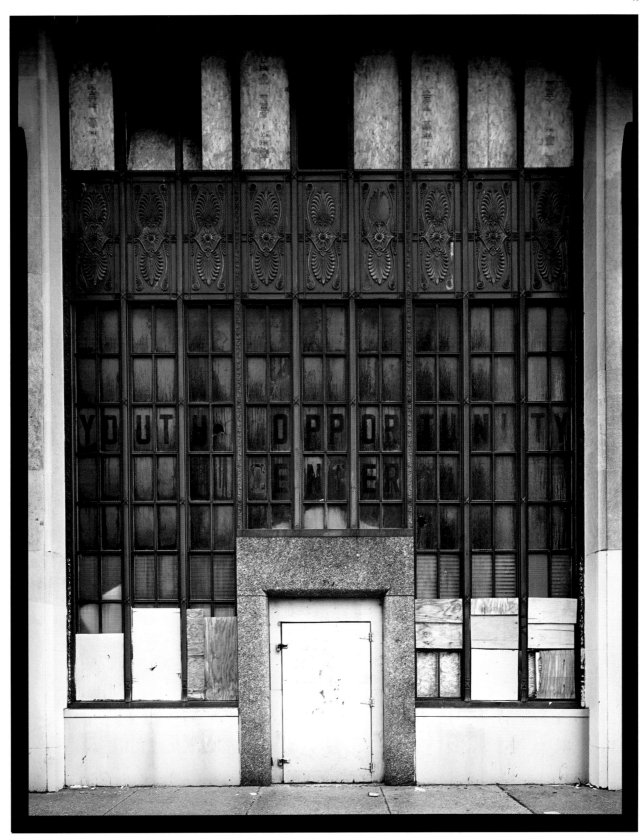

Youth Opportunity Center, 1997

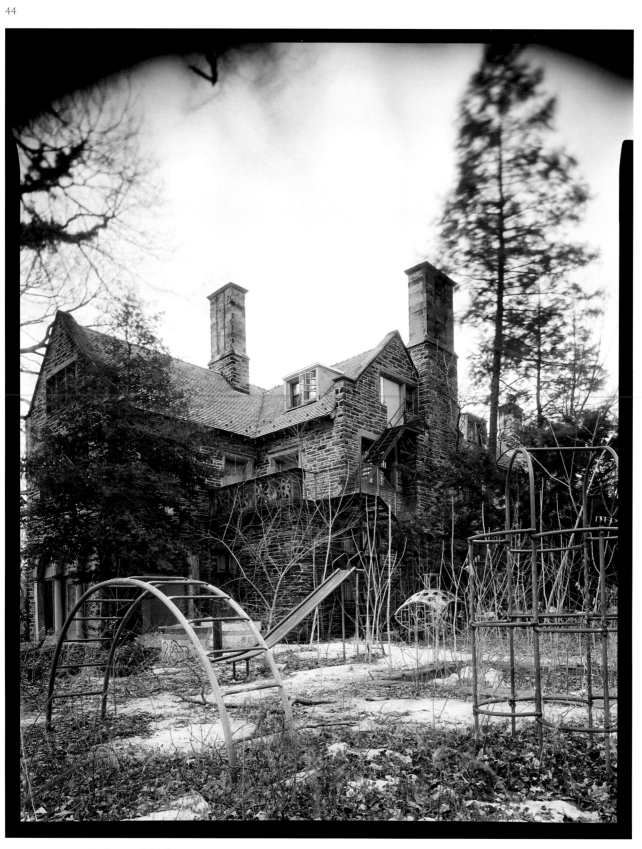

Parkgate, 1994

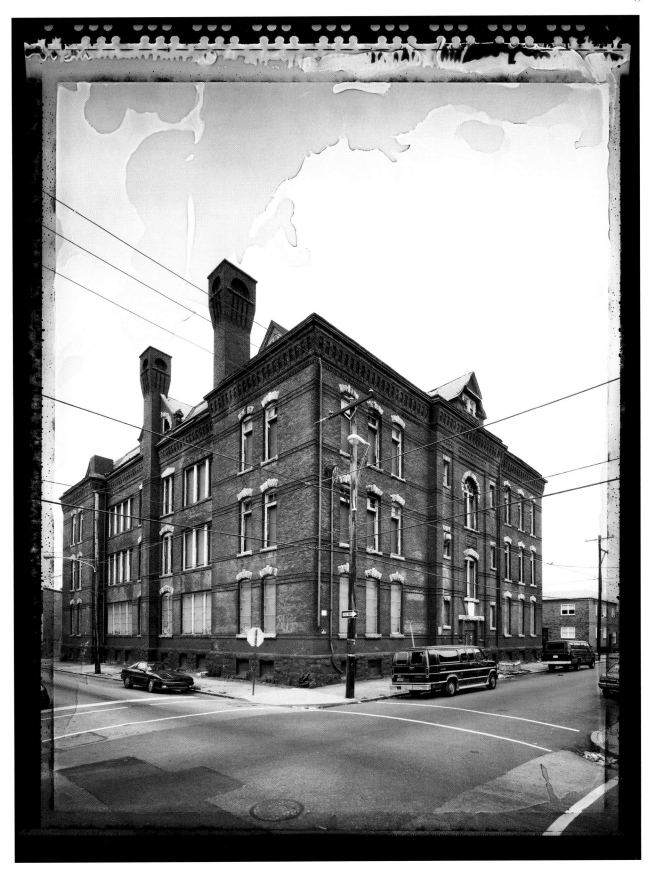

Francis M. Drexel School, 2000

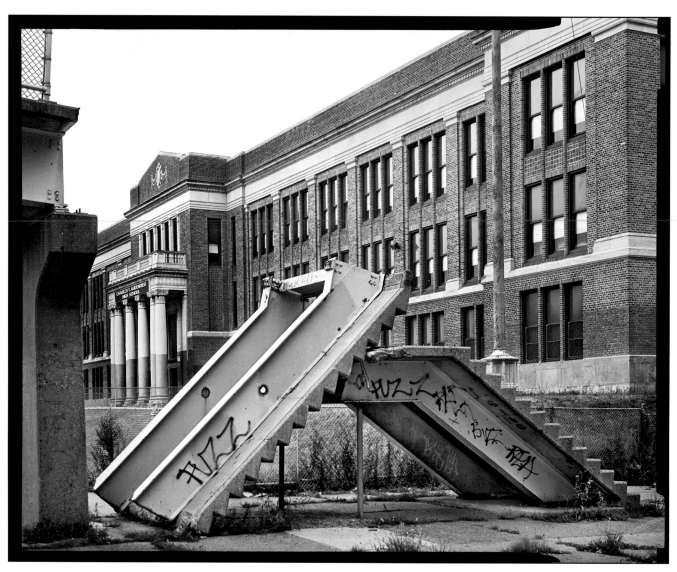

Charles Y. Audenried High School, 1996

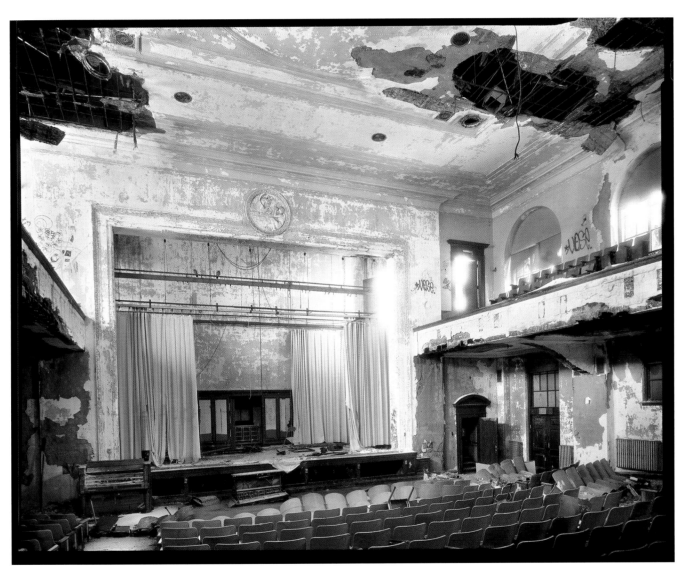

Cheltenham High School, 1994

Commerce

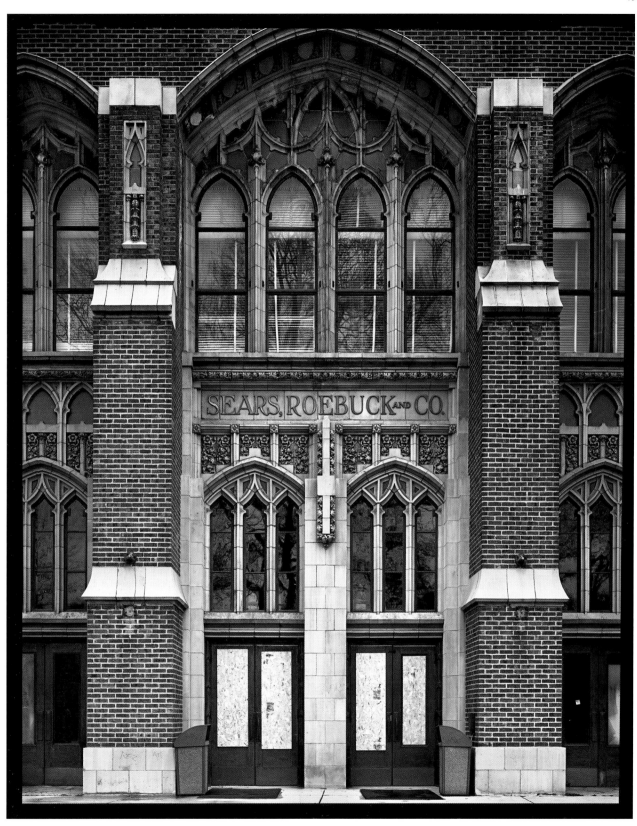

Sears, Roebuck & Company, 1994

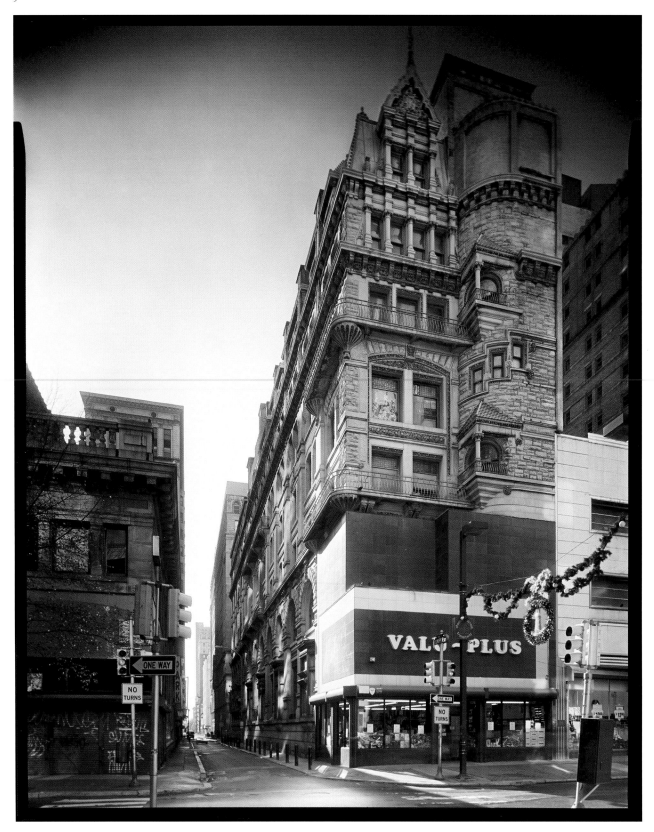

The Hale Building, 1994

The Victory Building, 1993

The Divine Lorraine Hotel, 2005

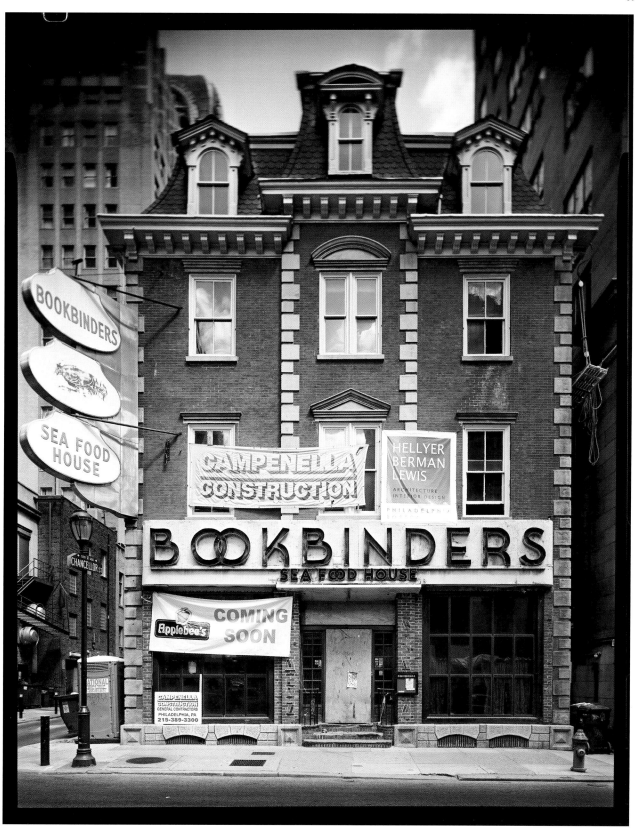

Bookbinders Seafood House, 2005

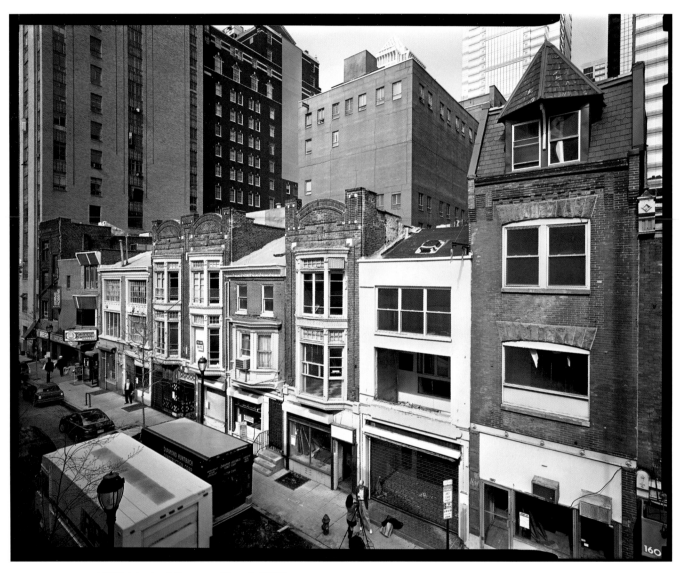

1600 block of Sansom Street, 2000

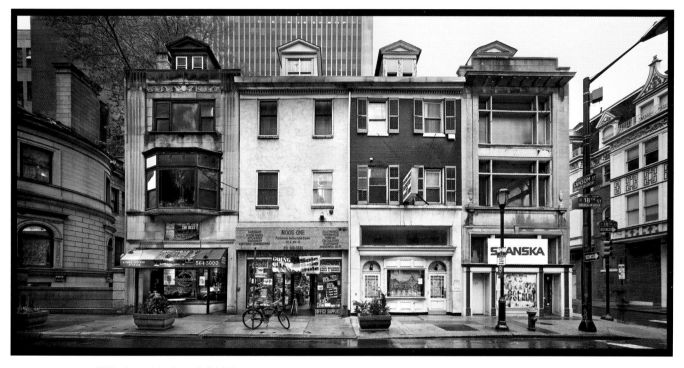

"Rindelaub's Row," 2005

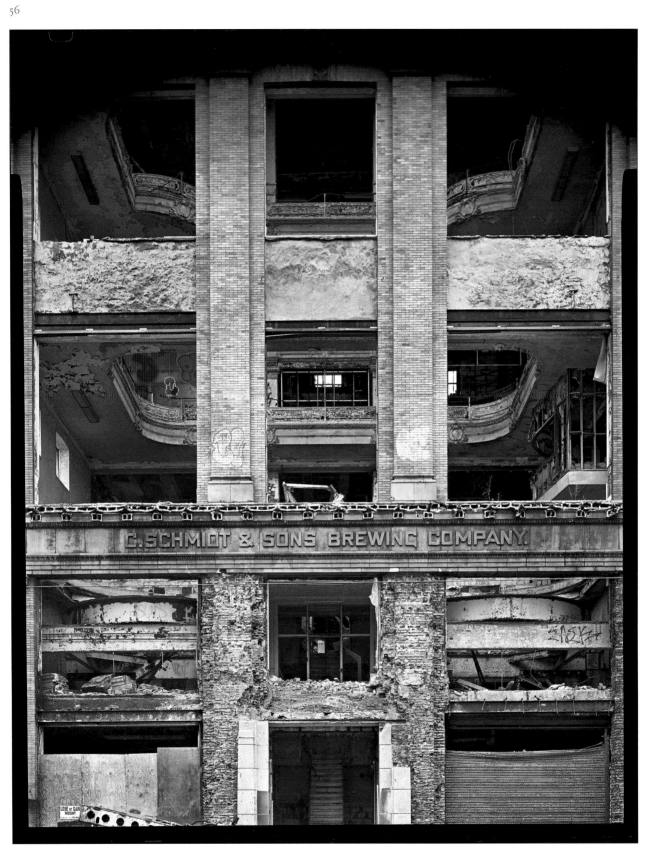

C. Schmidt & Sons Brewery, 2001

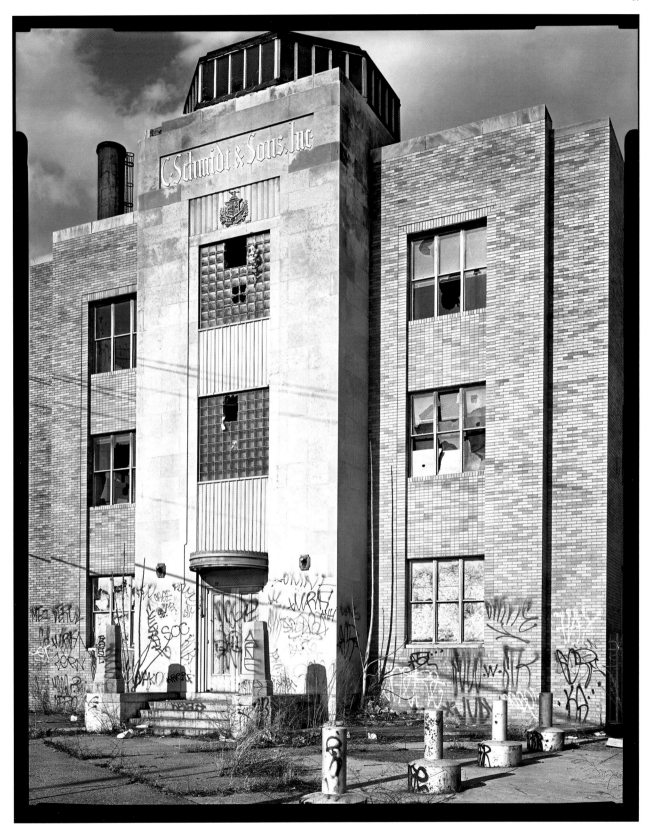

C. Schmidt & Sons Brewery, 1994

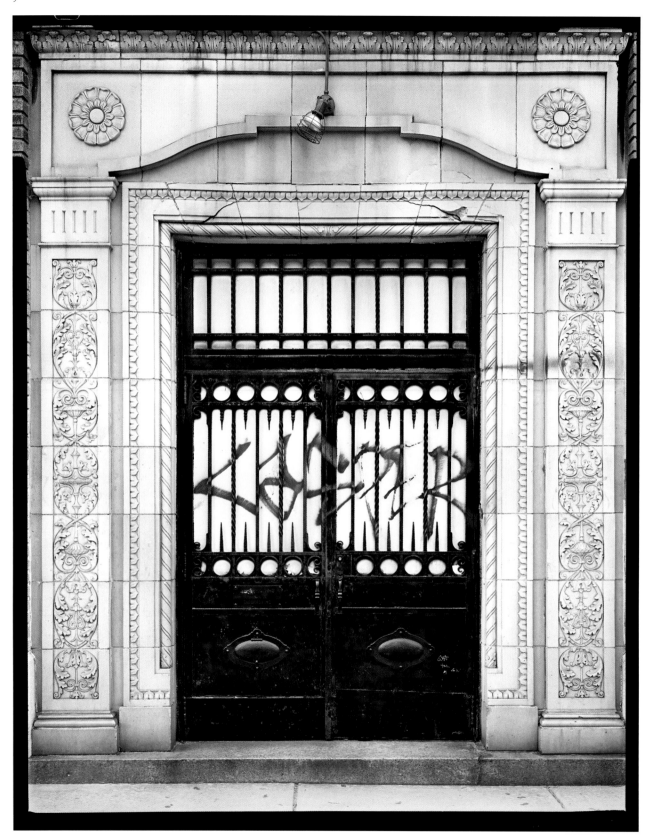

U.S. Bank Note Company, 1999

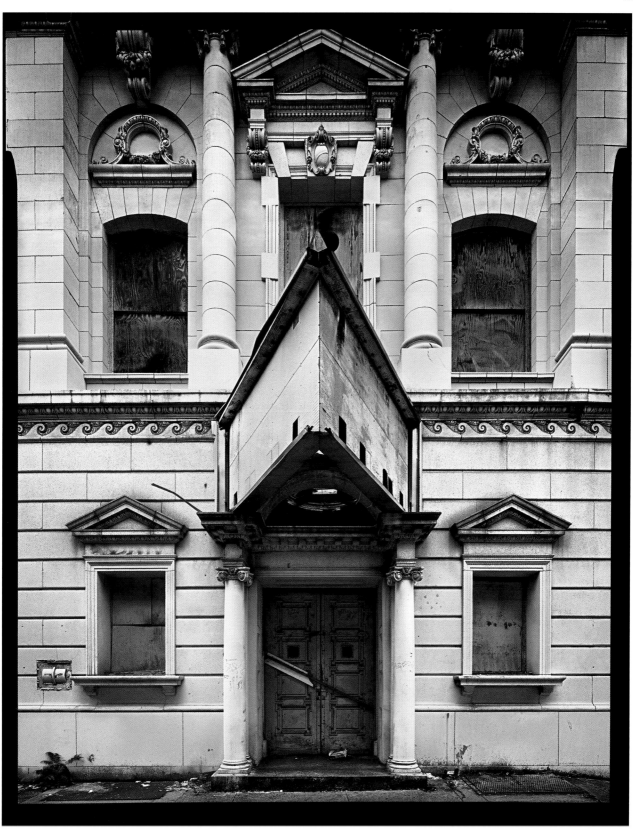

Industrial Trust, Title and Savings Bank, 2002

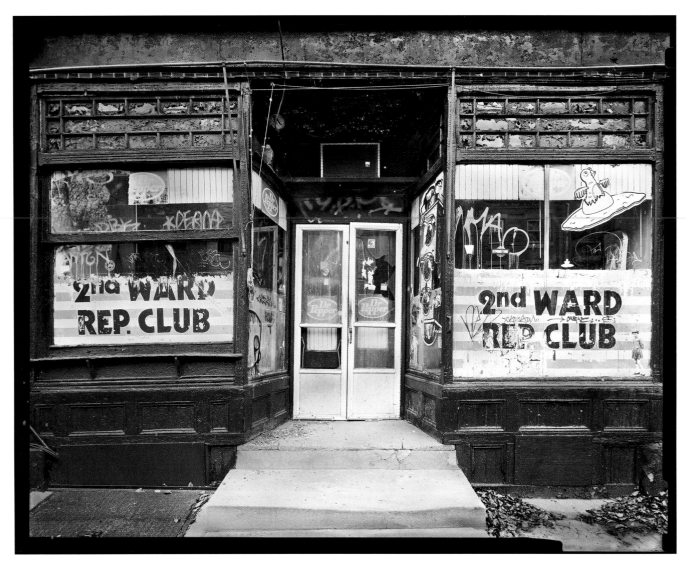

Second Ward Republican Club, 2005

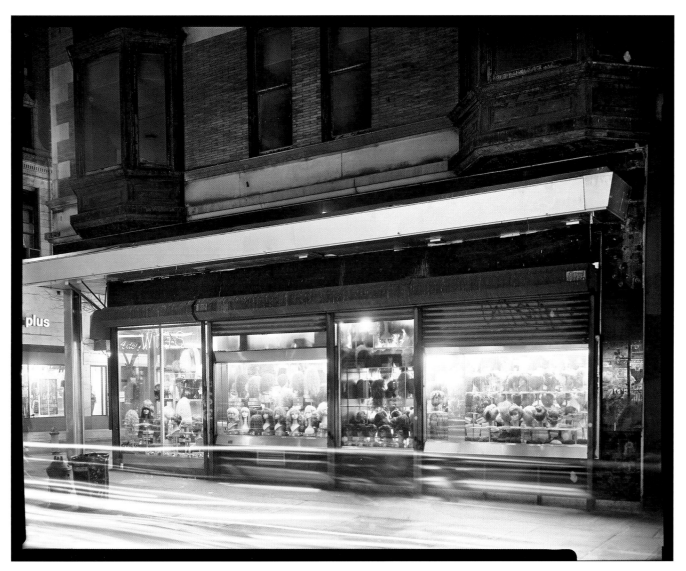

The Delong Building, 1994

Transportation

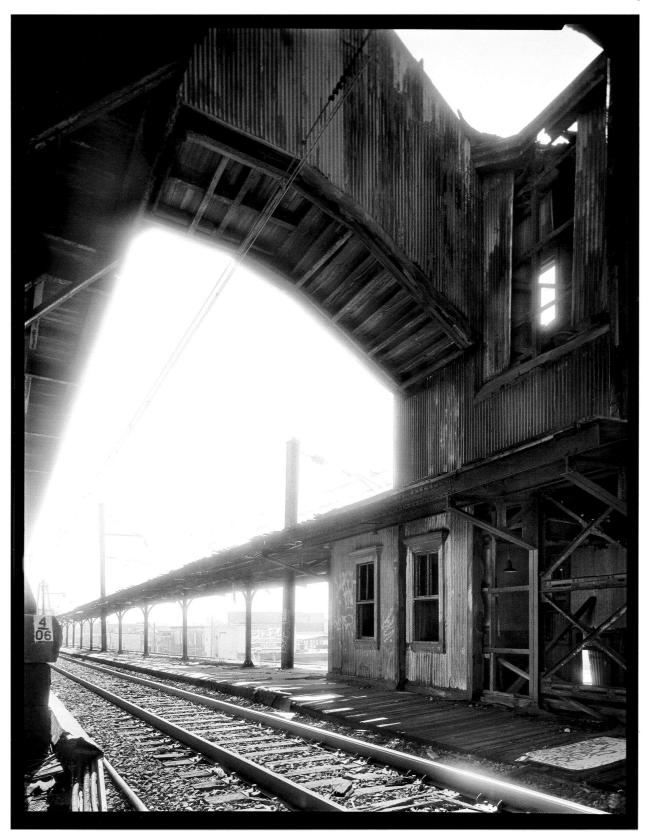

52nd Street Station, 1995

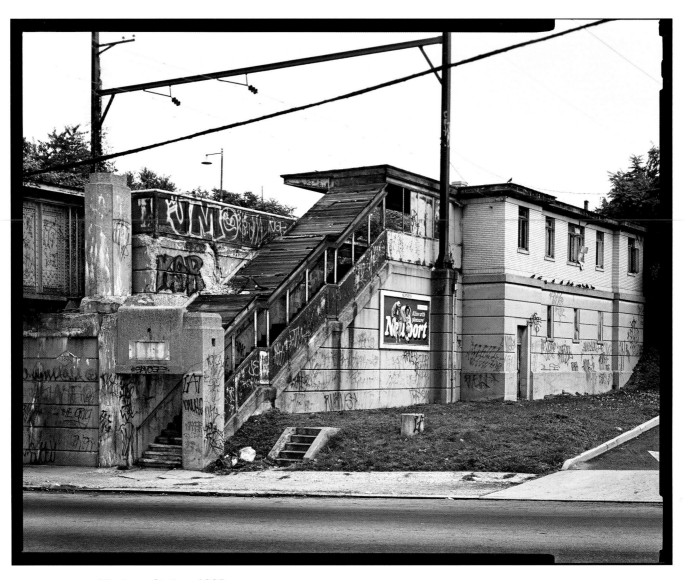

Allegheny Station, 1995

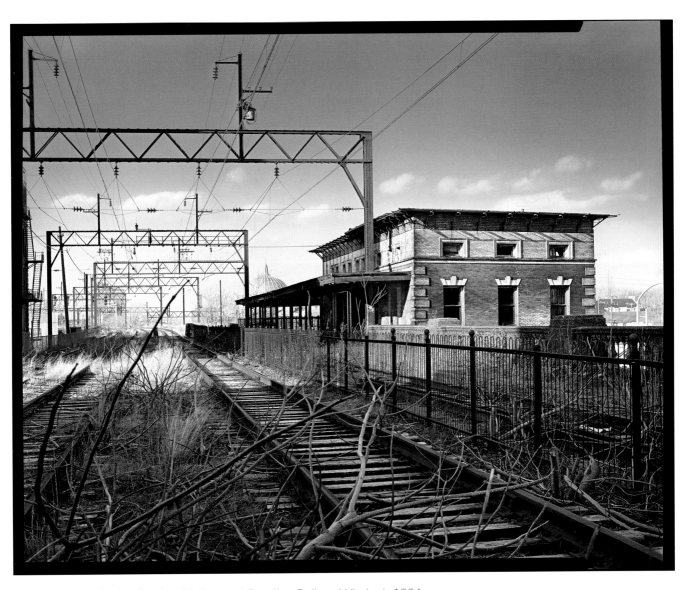

Spring Garden Station and Reading Railroad Viaduct, 1994

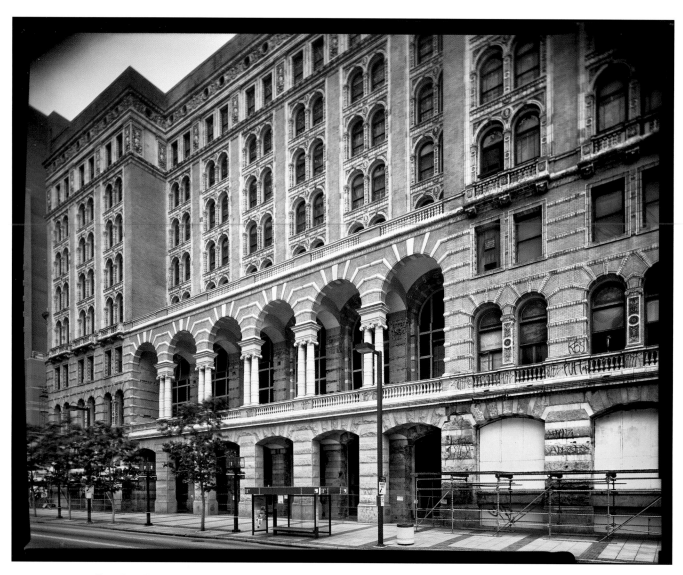

Reading Terminal Head House, 1995

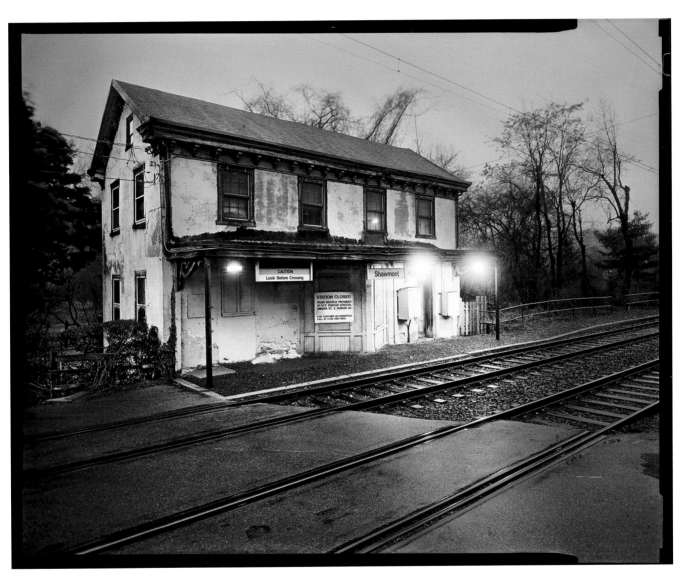

Shawmont Station, 2004

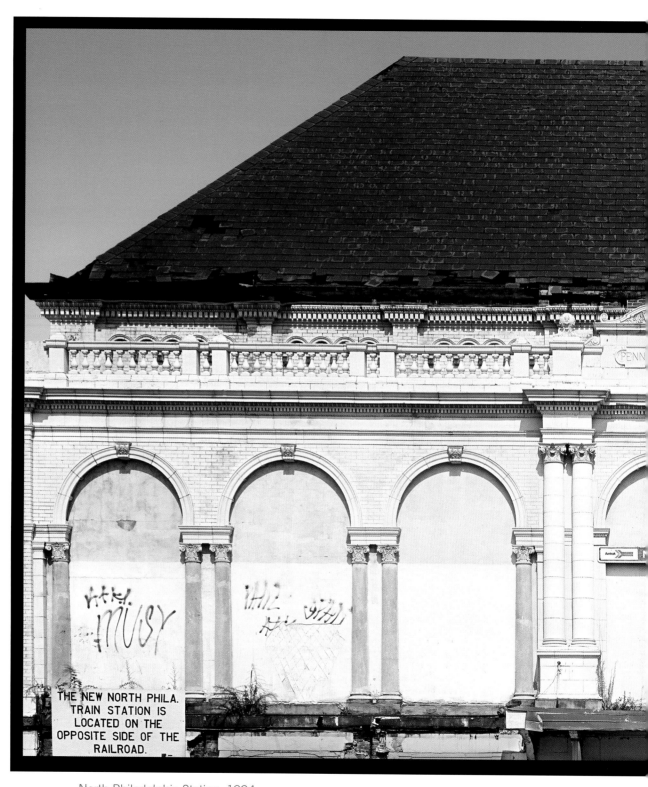

North Philadelphia Station, 1994

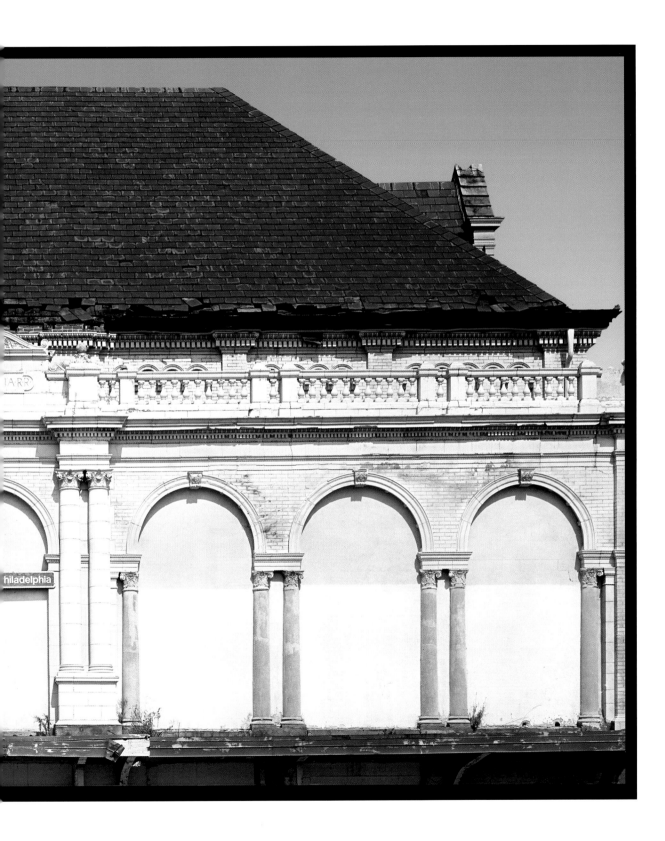

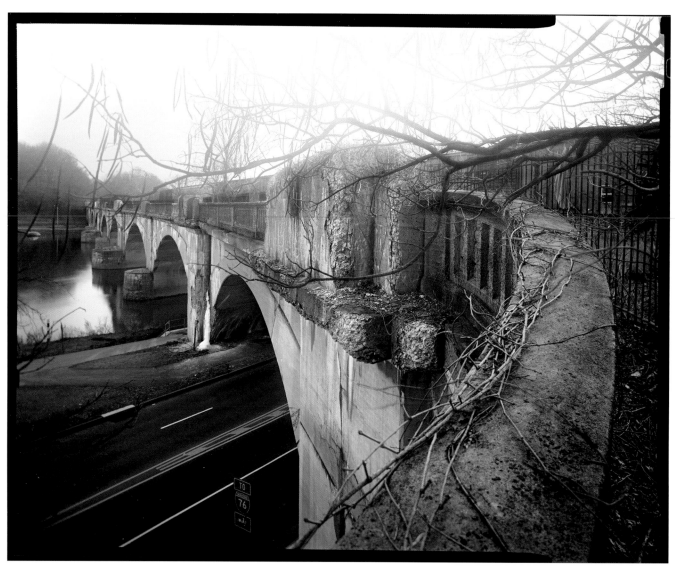

Columbia Bridge, 1997

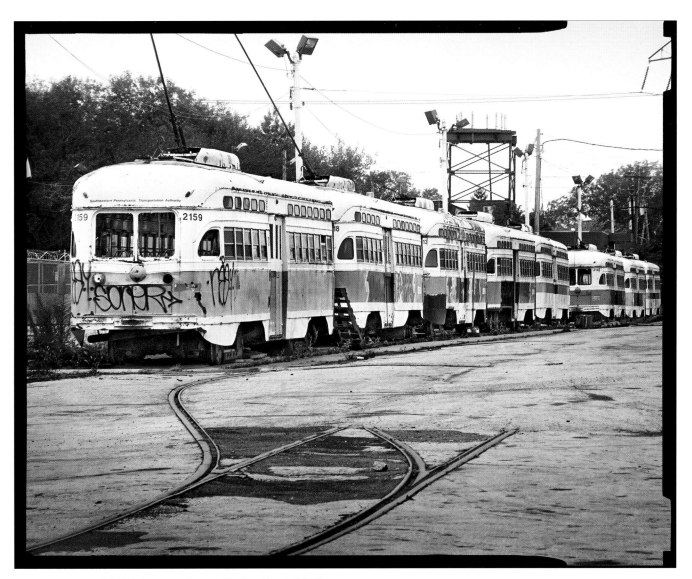

SEPTA Luzerne Depot Trolley Yard, 2002

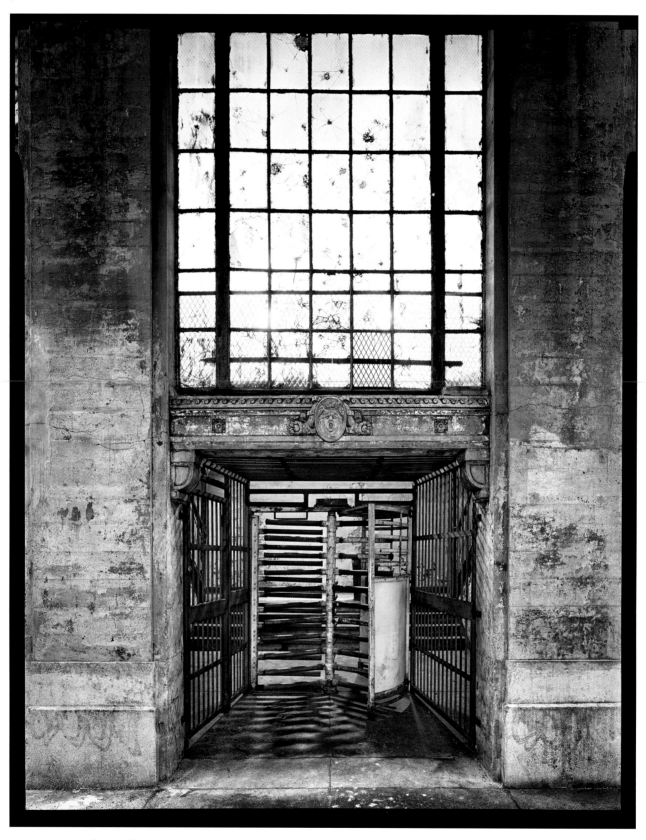

Berks Station, Frankford Elevated, 1998

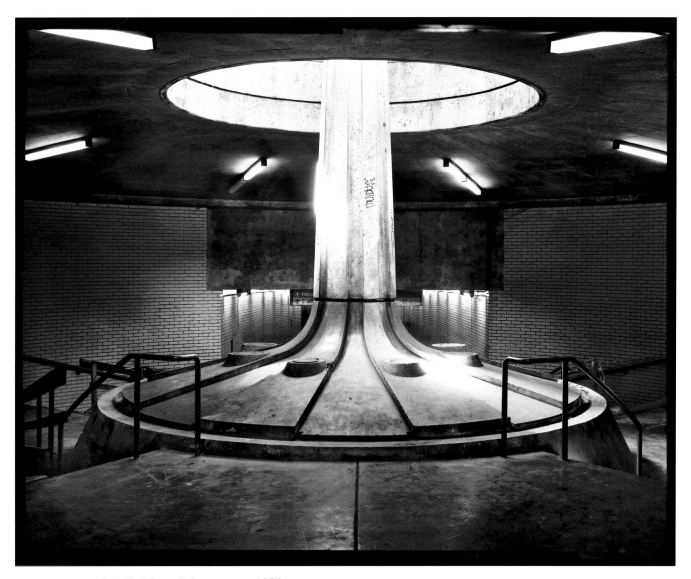

City Hall Transit Concourse, 1993

Culture

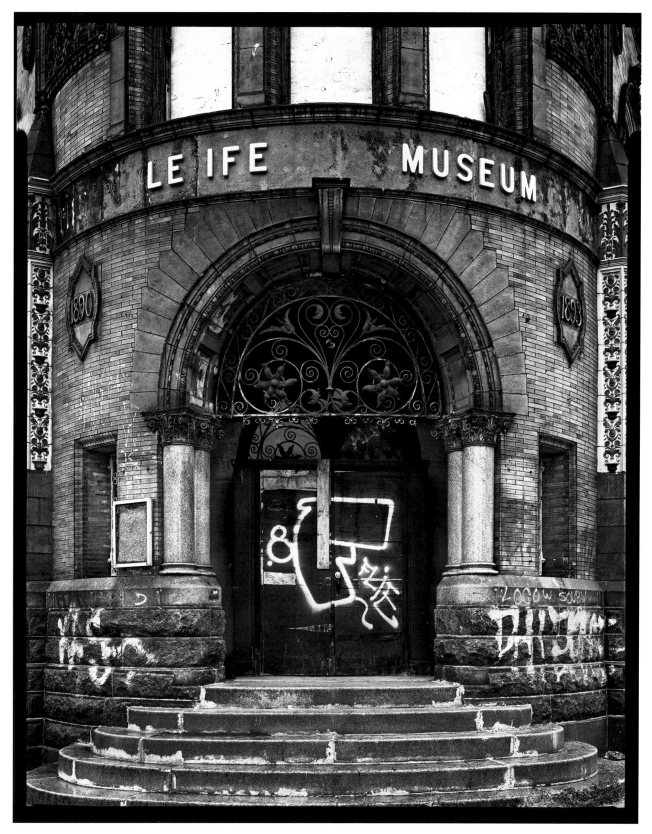

Ile Ife Museum of Afro-American Culture, 1994

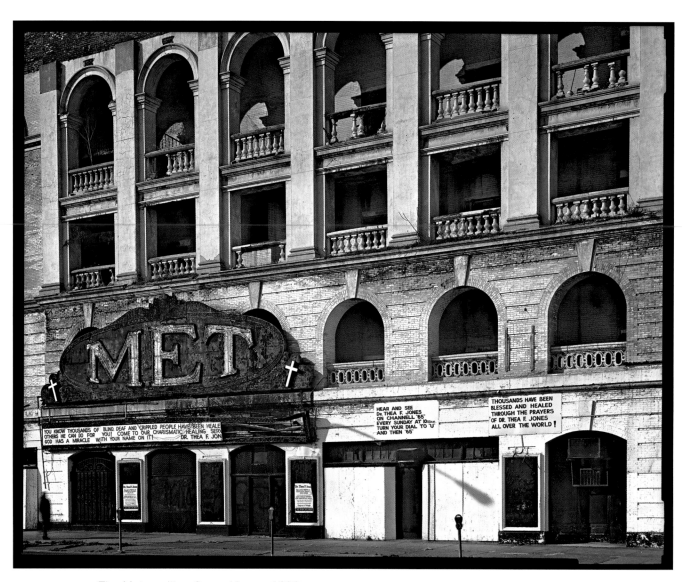

The Metropolitan Opera House, 1993

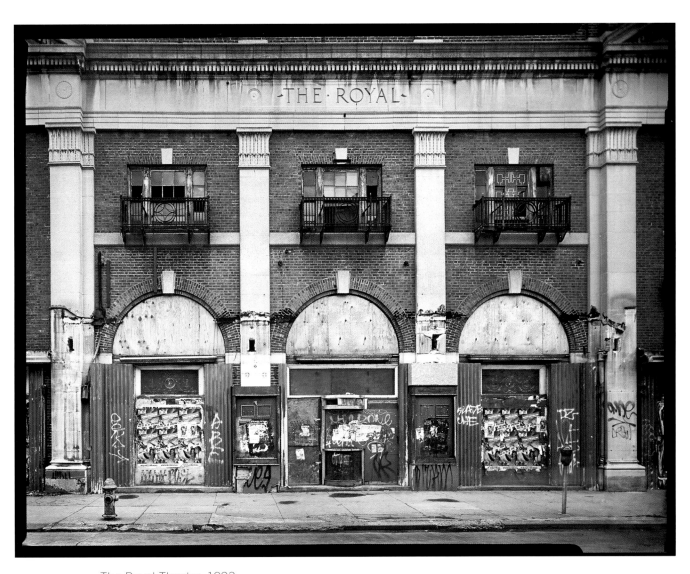

The Royal Theater, 1993

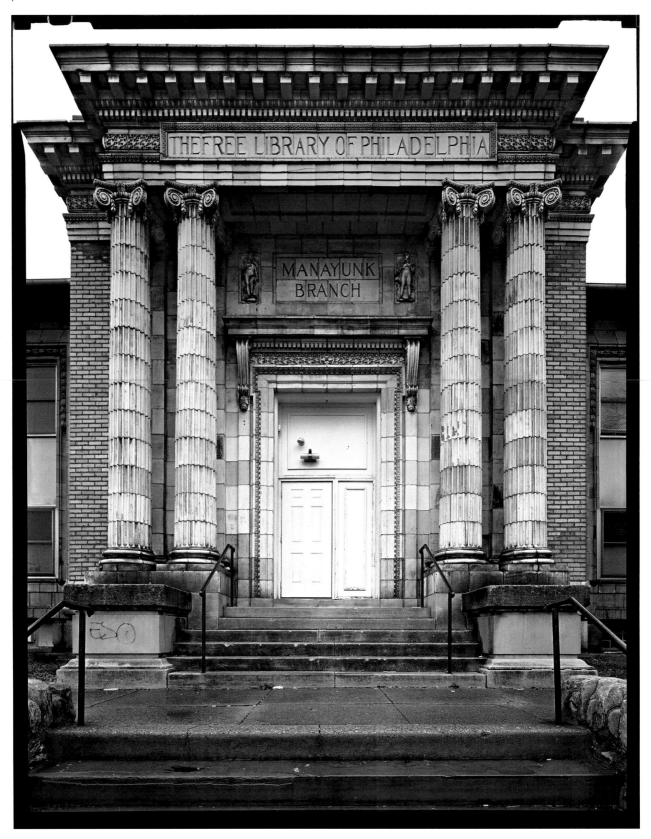

Manayunk Branch of the Free Library, 2000

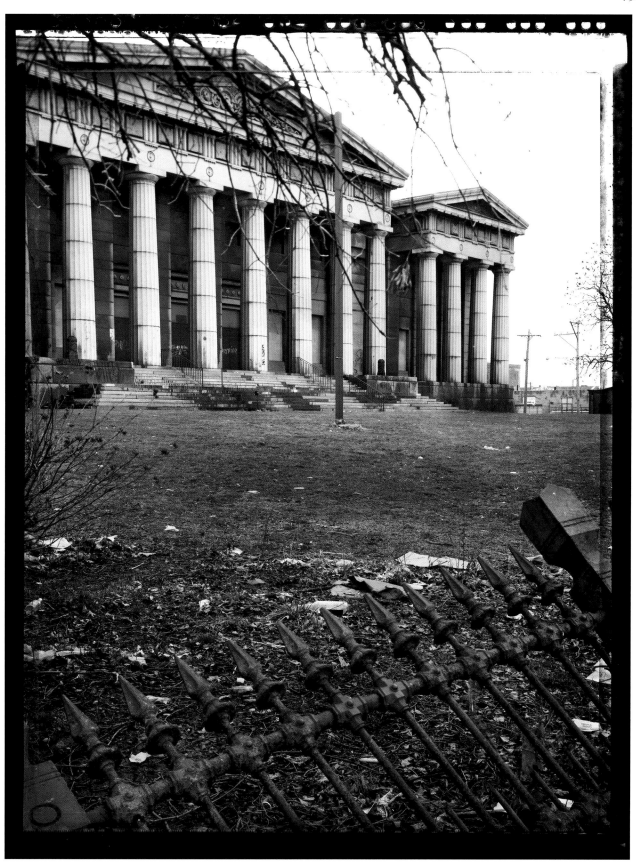

Ridgway Library, 1993

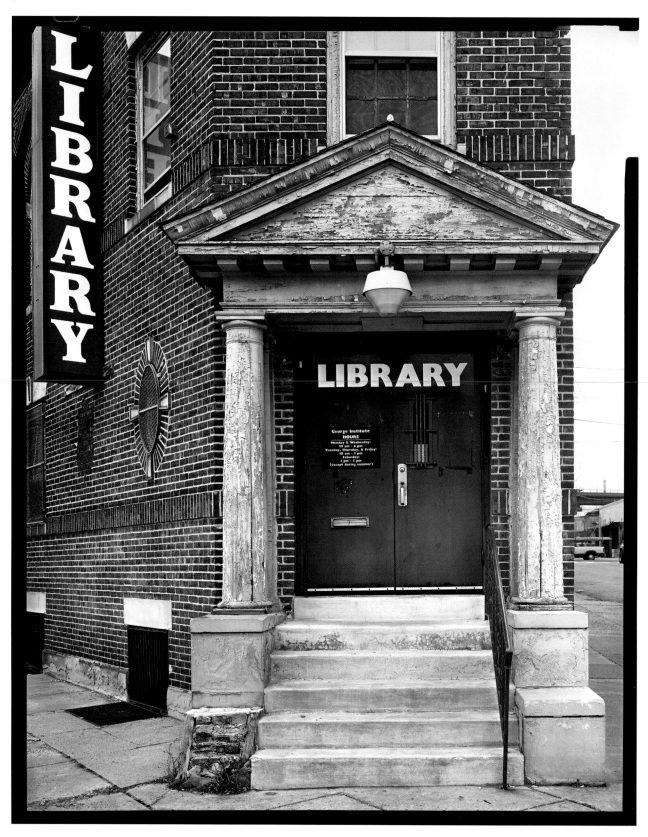

George Institute Branch of the Free Libary, 2005

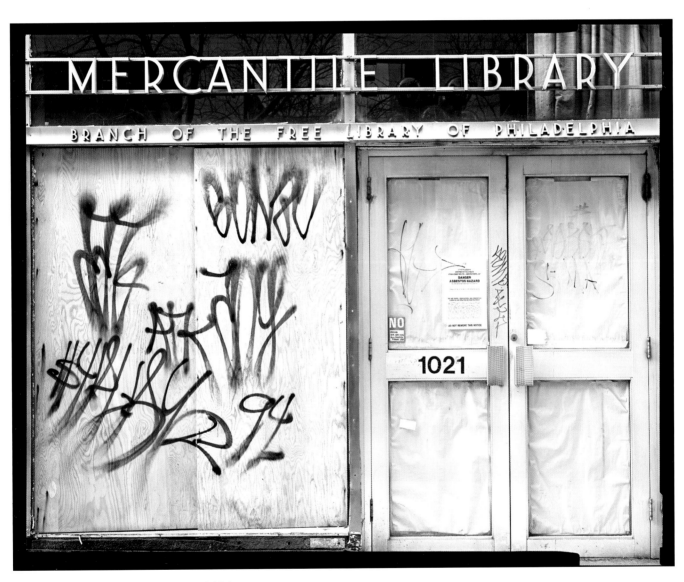

Mercantile Library, 1994

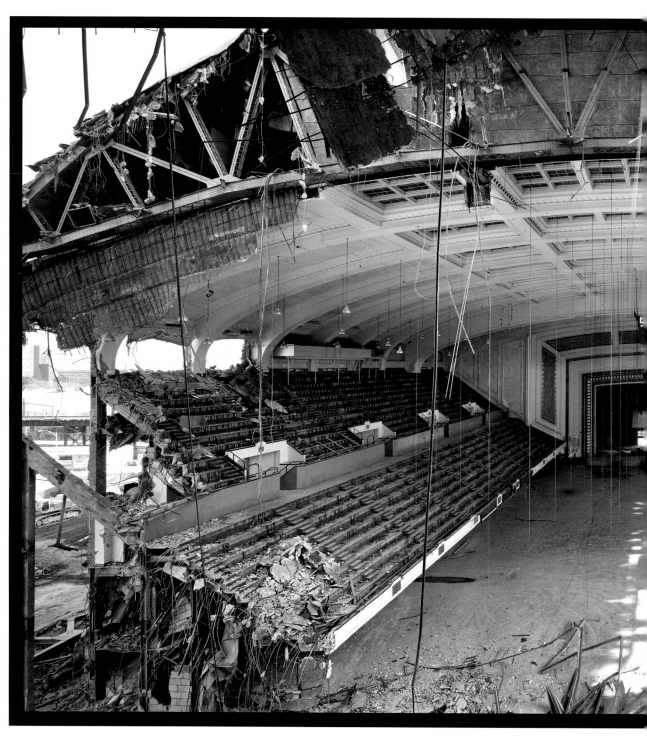

Convention Hall, 2005

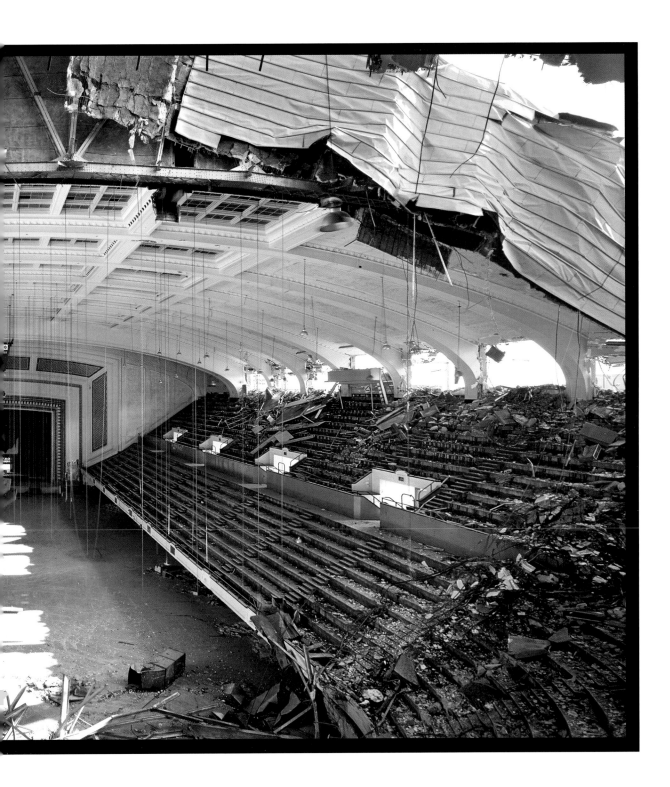

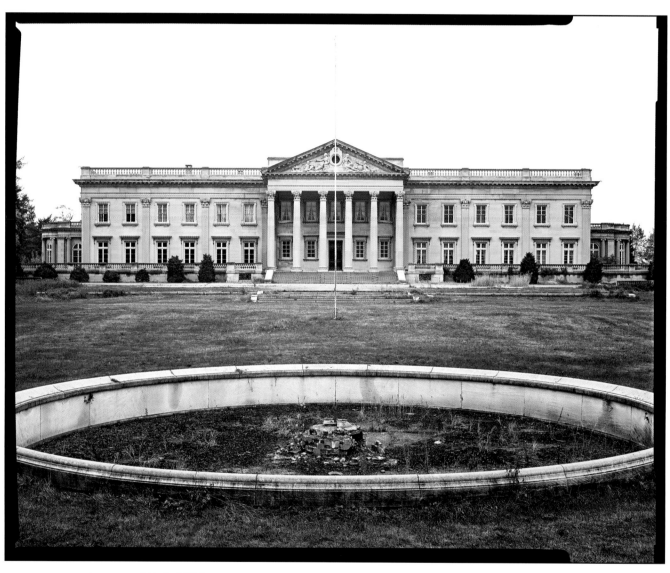

Lynnwood Hall, 1994

The Commercial Museum, 1997

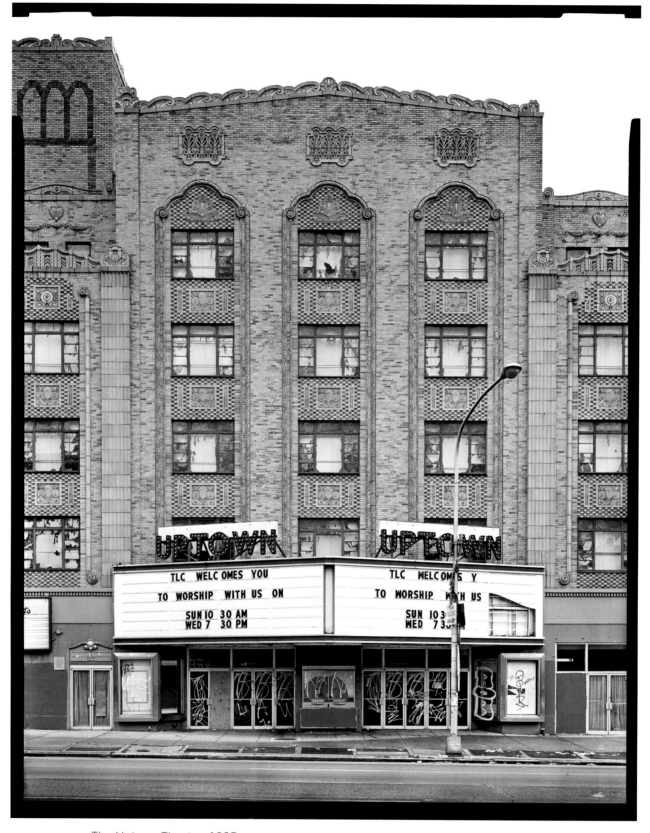

The Uptown Theater, 1995

The Philadelphia Pyramid Club, 1999

Religious Buildings

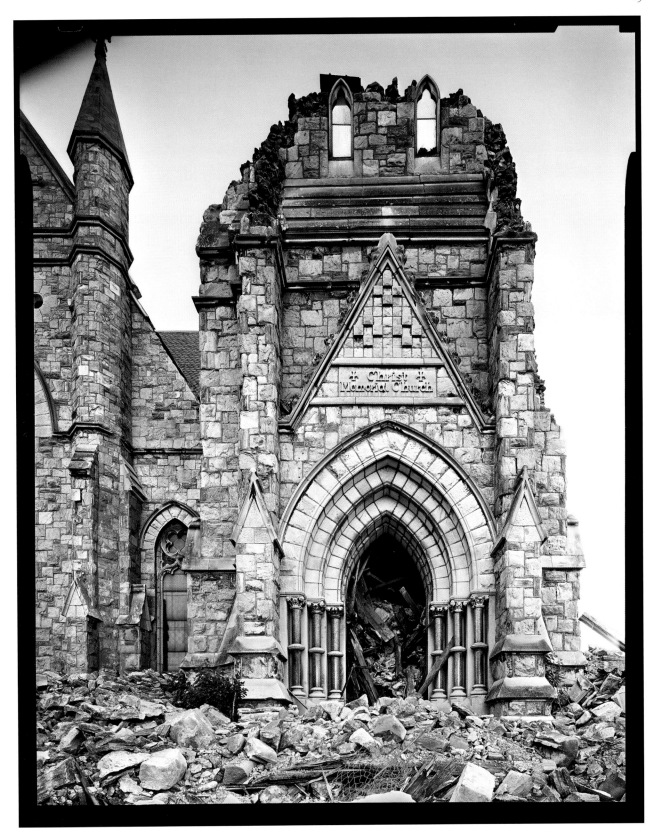

Christ Memorial Church, 2004

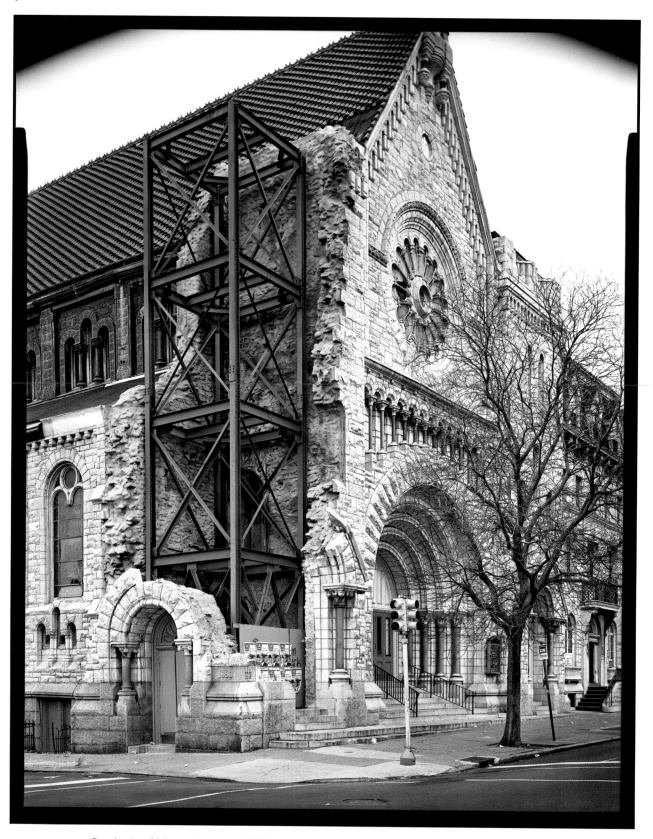

Our Lady of Mercy Church, 1995

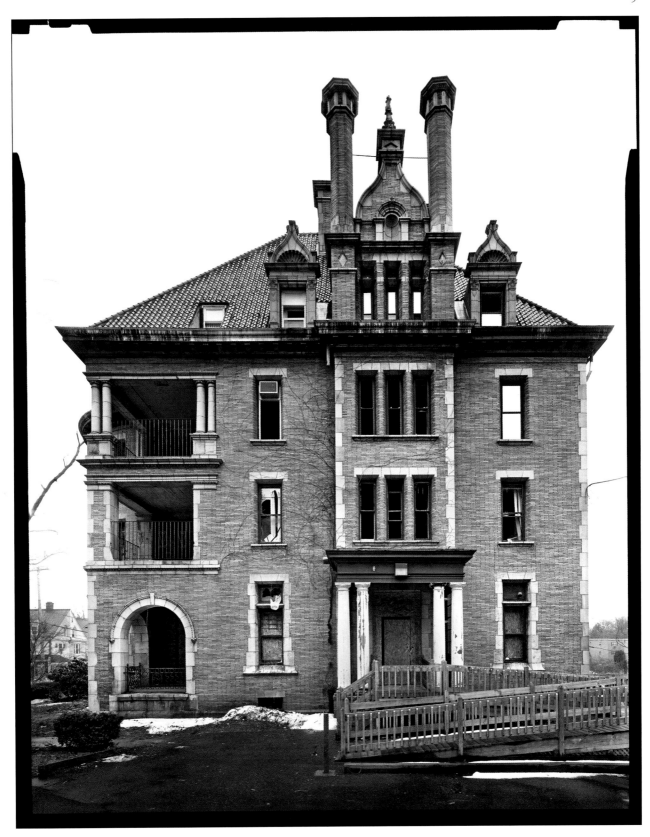

The Nugent Home for Baptists, 2004

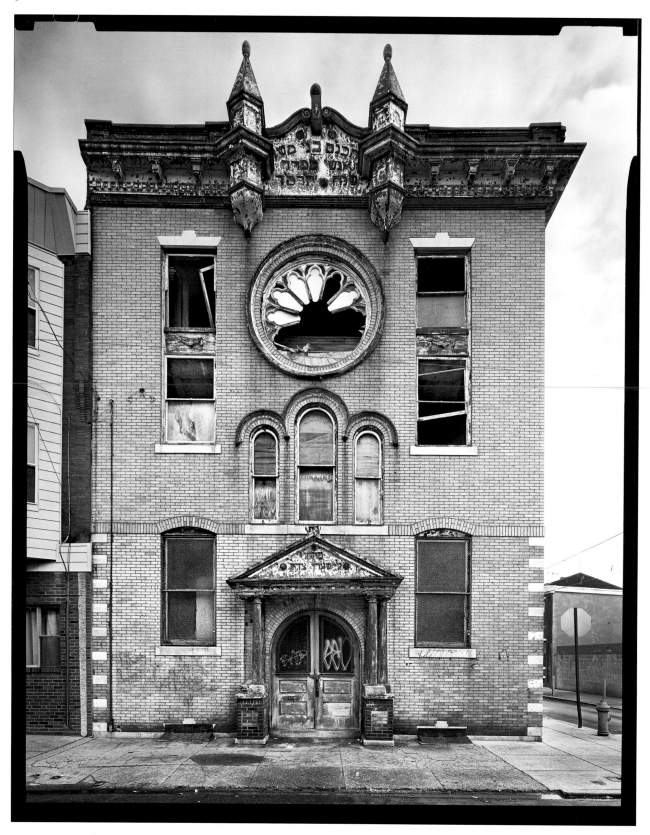

B'nai Moshe Anshe Sfard Synagogue, 1998

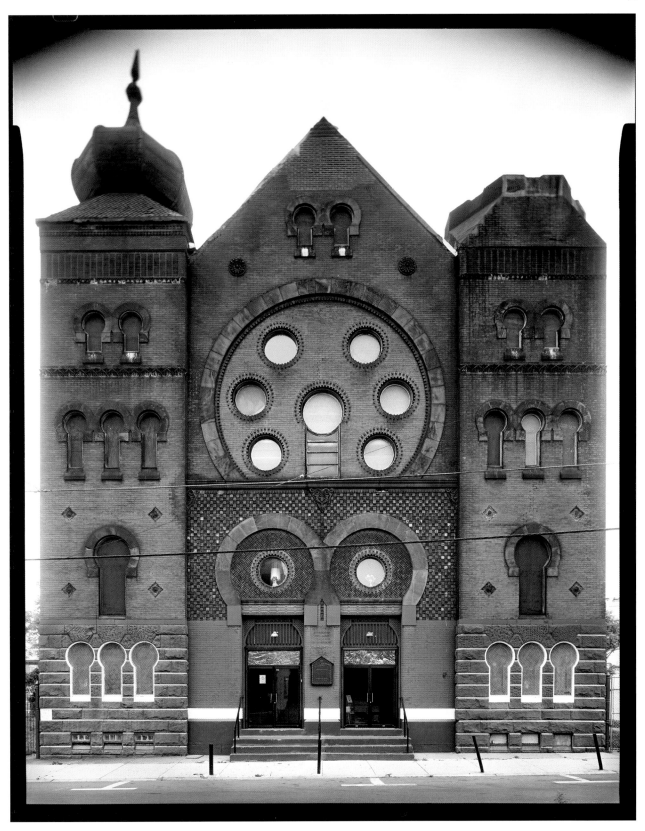

Adath Jeshurun Synagogue, 2002

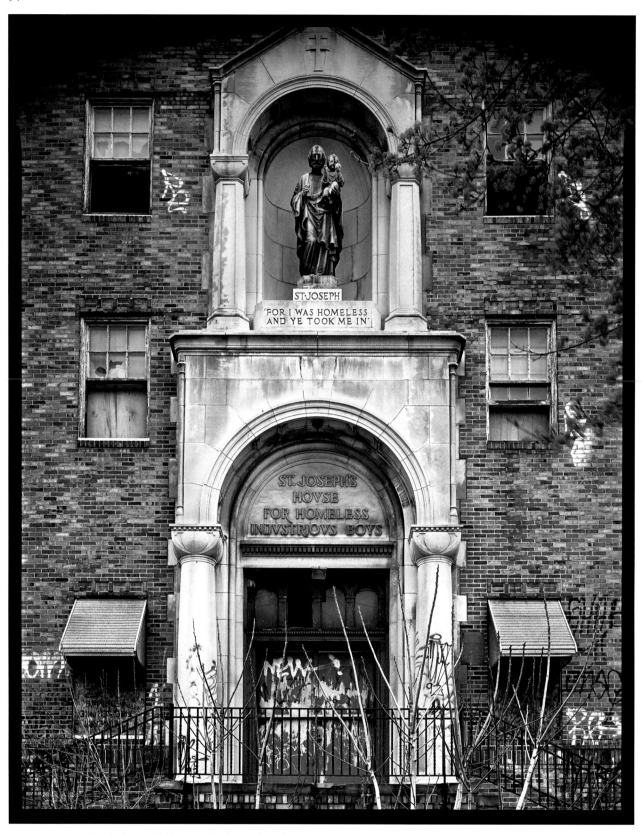

Saint Joseph's House for Homeless Industrious Boys, 1994

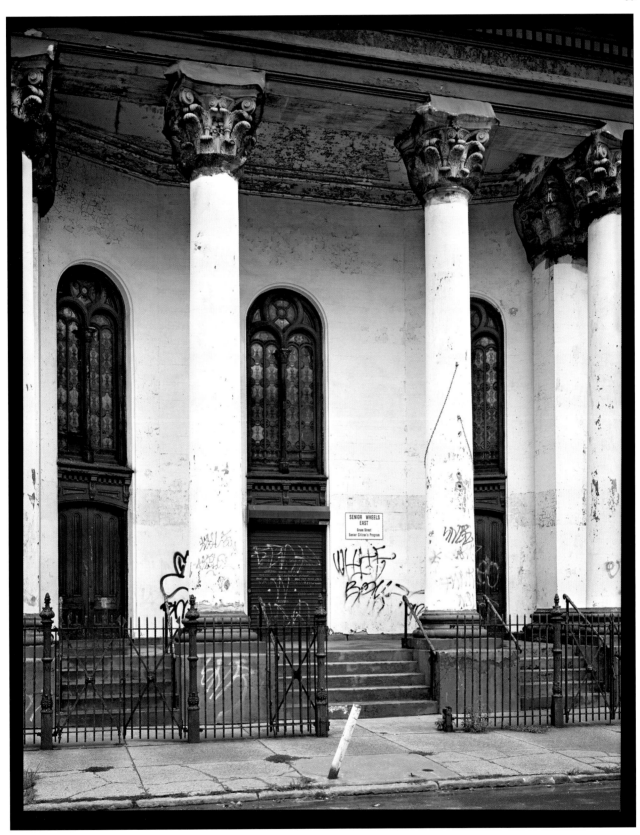

Green Street Methodist Church, 1995

Fairmount Park

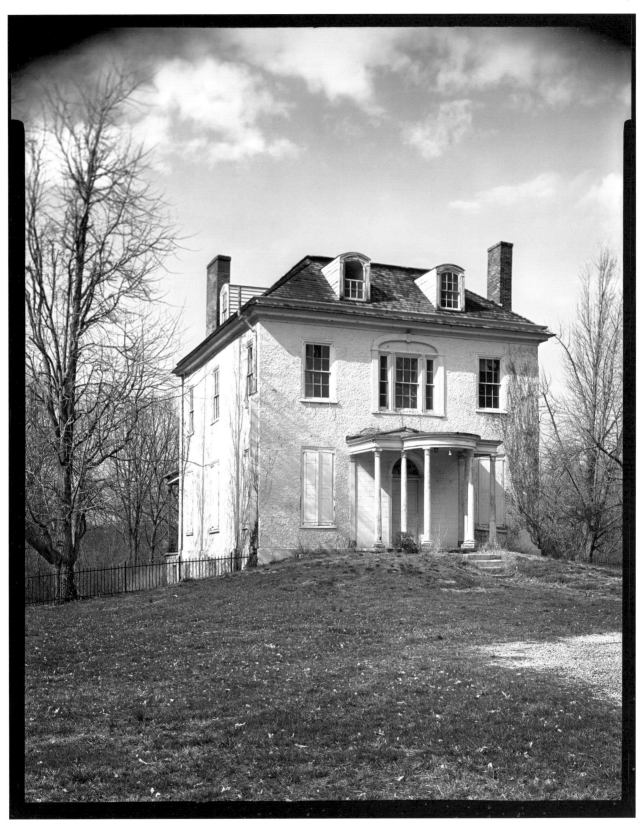

Rockland Mansion, 1996

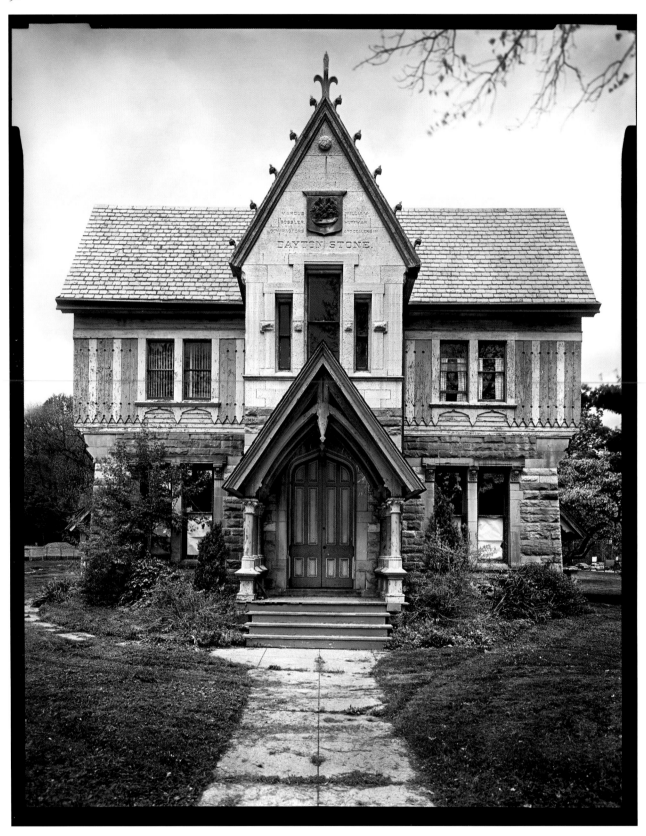

Ohio House, 2005

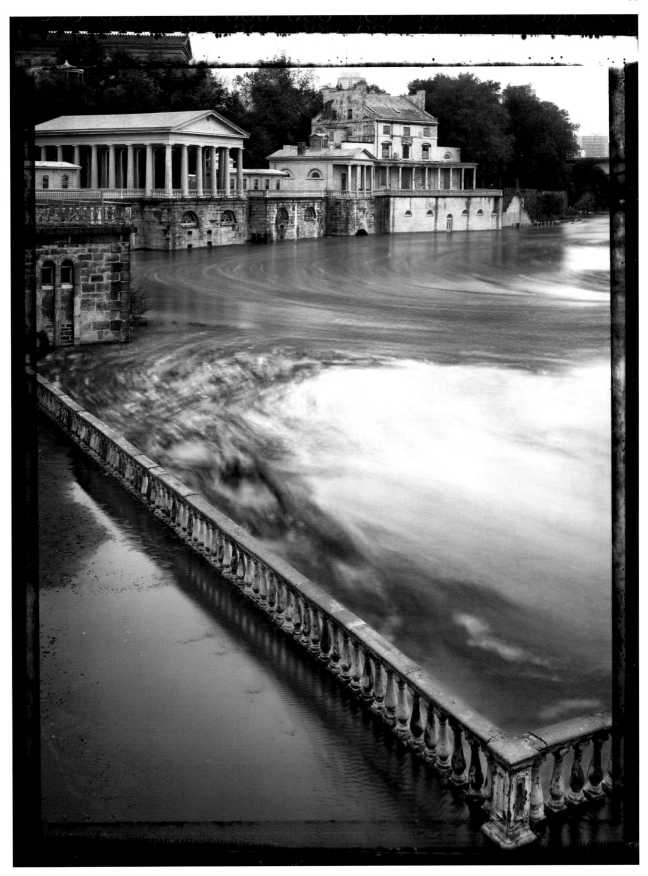

The Fairmount Water Works, 1996

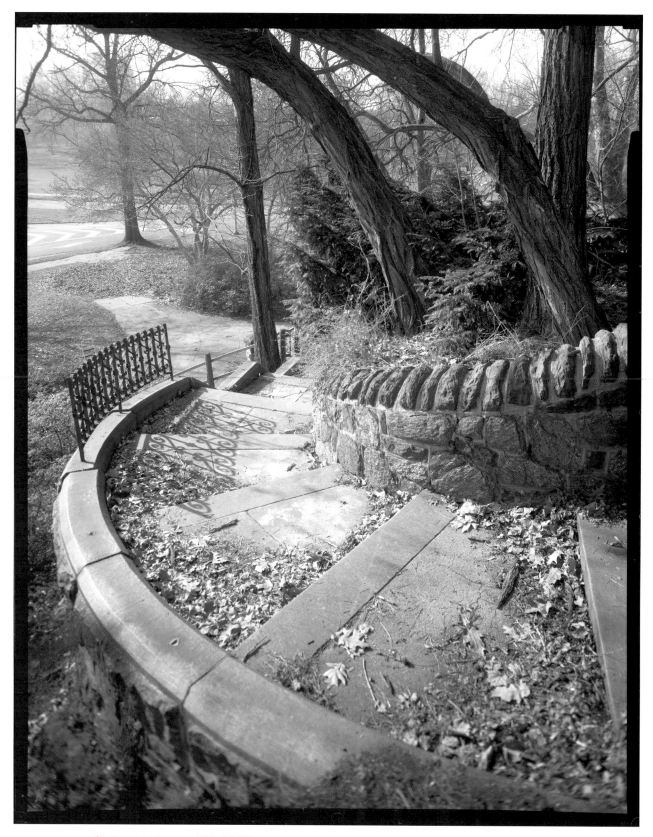

Stairway to Lemon Hill, 1997

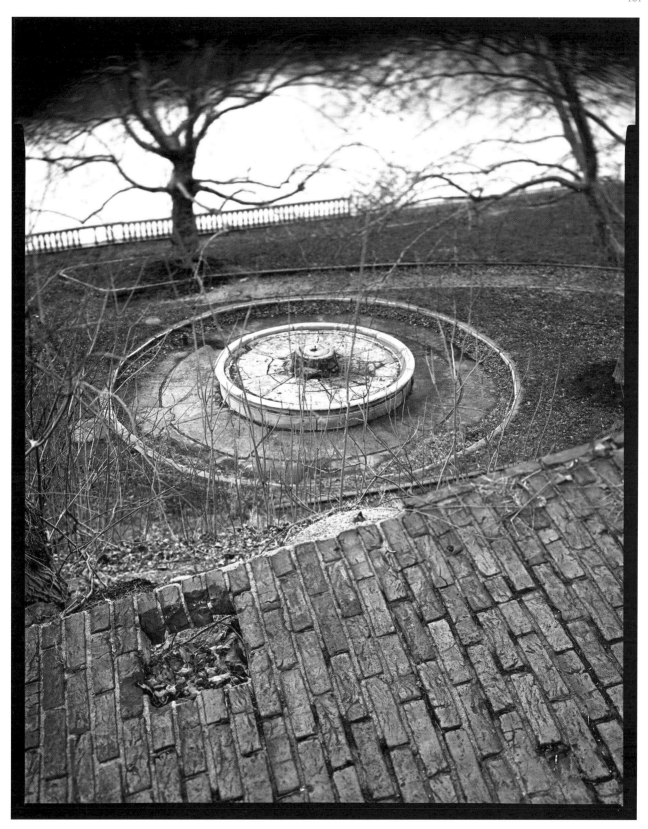

The Water Works Gardens, 1996

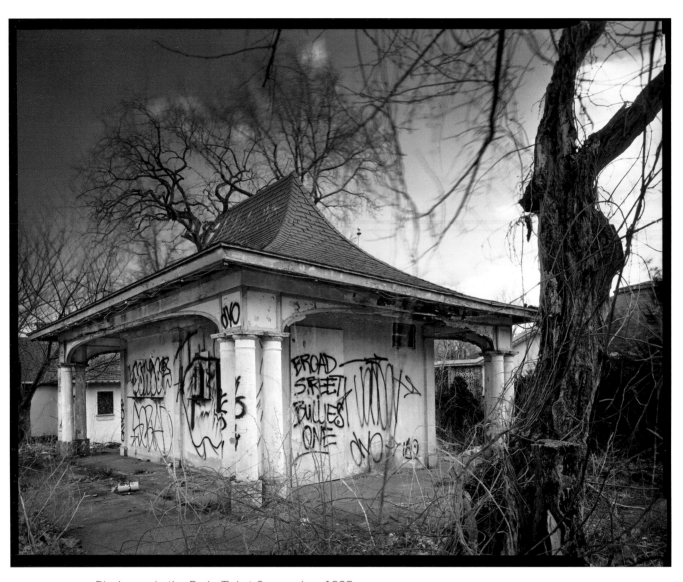

Playhouse in the Park, Ticket Concession, 1995

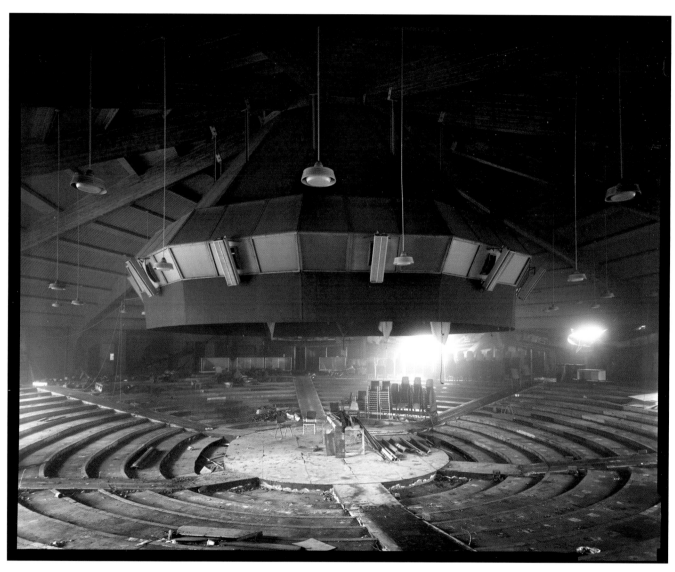

Playhouse in the Park, 1997

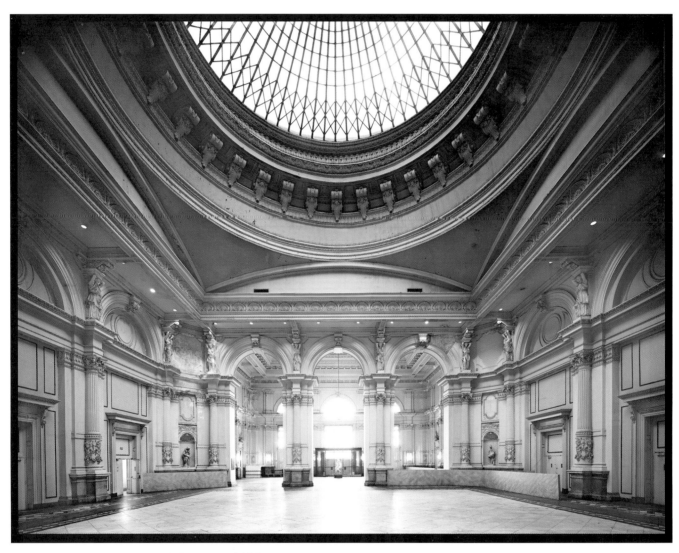

Memorial Hall, Rotunda, 2005

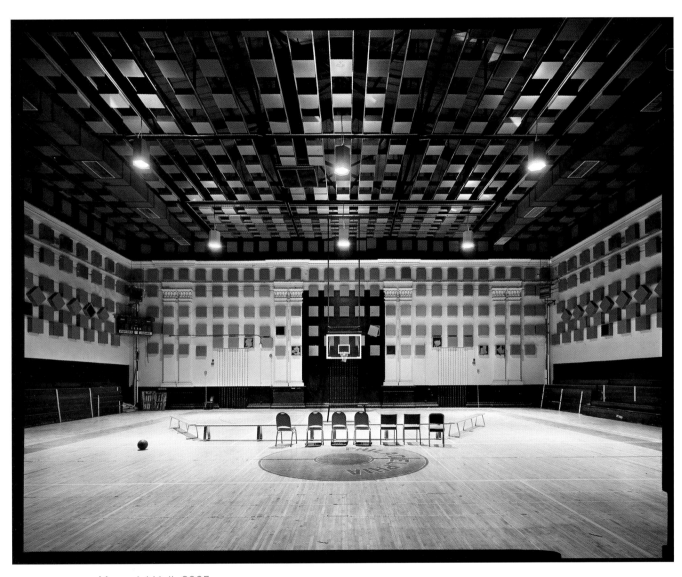

Memorial Hall, 2005

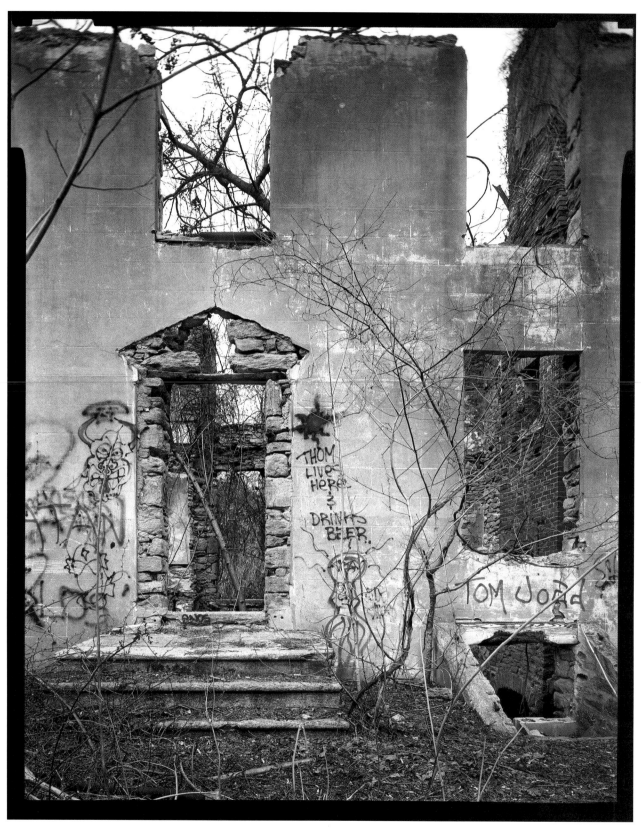

The Cliffs, 2005

Drinking Fountain, Wissahickon Valley Park, 2005

Factory Detail, 210 North 13th Street, 1995. Demolished 1999.

Appendix

Government

Germantown Hall

5928–5930 Germantown Avenue
John Penn Brock Sinkler, architect, 1923
Philadelphia Register of Historic Places
Photograph, 1997

The original Germantown Hall, built in 1854, was the center of government for an independent Germantown prior to its incorporation into the City of Philadelphia. Later rebuilt by the city, it housed a variety of city offices and a police station. Problems created by decades-long deferred maintenance eventually forced all the city offices to move. The last Philadelphia city department along with the Mayor's Action Center left in 1995. Neighborhood residents petitioned the city not to abandon this landmark building, which is modeled after William Strickland's Philadelphia Merchant's Exchange. Its decline mirrored that of the surrounding neighborhood. Soon after the building was vacated, its towering bronze lampposts were stolen. As much as a million dollars designated for the Hall's restoration went missing from a City Council member's accounts in 1993 following his death. In 2010 neighborhood residents again began circulating a petition requesting that the city house some city or community services in the now crumbling landmark. Since 2005 the city has tried to sell the vacant property with an asking price of $300,000.

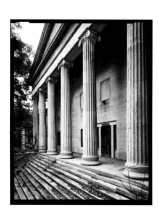

United States Naval Asylum

Grays Ferry Avenue and 24th Street
William Strickland, architect, 1827–1833
National Historic Landmark
National Register of Historic Places
Pennsylvania Register of Historic Places
Philadelphia Register of Historic Places
Photograph, 1993

Considered one of the most important extant examples of Greek Revival architecture in America, Biddle Hall is the main building on this twenty-acre campus. In its early years, it served as the first United States Naval Academy and the Navy's home for retired sailors (the first federal veterans retirement facility) and as a Naval hospital. In 1976 when the Navy closed the Naval Home and moved the residents to a new facility in Mississippi, the building was in good condition. The federal government advised the city that it was de-accessioning the property in the early 1980s. The city encouraged neighbors to develop a suitable plan for the site and funded several studies on its reuse. When the property went to bid, the city made no attempt to acquire it, and it was sold to the only bidder—Toll Brothers, one of the nation's largest residential developers. Toll Brothers purchased the property for $1.2 million. Because of the historical significance of the property, the sale had to be approved by the National Park Service, the

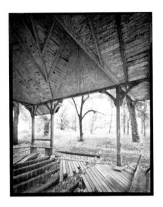

federal Advisory Council on Historic Preservation, the Pennsylvania Bureau of Historic Preservation, the Planning Commission, City Council, and the Historical Commission. It was an extraordinary achievement for a developer with no experience or expertise in the adaptive reuse of buildings. Once in control of the property, Toll Brothers sought permission to demolish all the structures except for Biddle Hall. When permission was not granted, the property was left abandoned for over twenty years. Community pressure was needed just to get the company to do simple grounds maintenance. In 2002 the developer was cited for using the tactic of "demolition by neglect" to remove the historic buildings it wished to clear. Biddle Hall was the target of an arsonist in 2003, but as a testament to the building's fire resistant design, only the roof was damaged. After being compelled by a court order to make repairs to the property, Toll Brothers built "Naval Square," a gated community and the second urban development for the company. It opened in 2006. The once lush campus is now home to over 600 dwelling units.

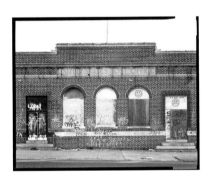

United States Post Office

West Park Station
1575–77 North 52nd Street
Architect unknown, c. 1928
Demolished
Photograph, 1995

This decommissioned postal branch was demolished by the city in the late 1990s. The land was donated to the nonprofit West Philadelphia Financial Services Institution. The group partnered with a large strip mall developer to build "Park West Town Center," a $50 million retail shopping center, which now covers the site. With about one-third of its funding subsidized by the city, state, and federal governments, the center opened in 2008, anchored by a Lowe's home improvement store, a supermarket, a McDonald's, and chain retail stores. This pattern of using public money to clear city land and attract large-scale developers and national chains first gained traction in the 1990s. With parking for a thousand cars and little pedestrian rights of way, this project exemplifies the city's emphasis on establishing a suburban formula for urban renewal during the two decades that straddled the turn of the new century.

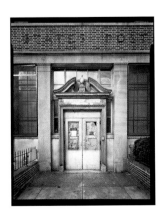

United States Post Office

736–738 South 52nd Street
Architect unknown, c. 1928
Photograph, 1997

During the 1980s and early 1990s, the United States Postal Service closed thousands of branches nationwide. Most neighborhoods in Philadelphia had their own postal branch, now there is typically only one per Zip Code, and some poorer Zip Codes are left without branches altogether. The Post Office once served as an immediate link between the American people and their government, and many were centers of their

communities. During the Great Depression many branches were graced with public art murals or hosted exhibitions of art. This West Philadelphia branch was sold in the late 1990s, and is now a funeral home. Under U.S. law, mail delivery is a "basic and fundamental" government function meant to "bind the Nation together" by providing service to "all communities" (39 USC § 101). The U.S. Postal Service is now judged on a profit-and-loss basis and not as an institution with a social purpose.

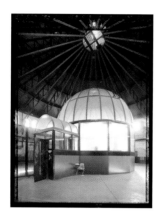

Philadelphia County Prison at Holmesburg

8215 Torresdale Aveune
Wilson Brothers & Company, architects, 1895
Photograph, 2002

This prison had become notorious due to its overcrowding, riots, torture, summary executions, and the murder of the warden and deputy warden by prisoners. The book Acres of Skin revealed in the late 1990s that scientific and non-medical experiments had been carried out on the inmates in the years between 1951 and 1974. The experiments were contracted by the U.S. Army Chemical Corps, the CIA, the University of Pennsylvania, and scores of pharmaceutical companies. They tested the effects of substances ranging from deodorants and skin creams to radioactive isotopes and biochemical warfare agents.

Originally built to accommodate six hundred prisoners, Holmesburg routinely held more than twice that number. It was closed in 1995, but due to a surge in the city's prisoner population the 19th-century prison was reopened in 2006, despite its deteriorating condition. Currently its gymnasium houses the overflow of the city's prisoners. The rest of the prison is a crumbling ruin.

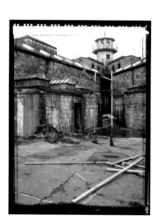

Eastern State Penitentiary

2124 Fairmount Avenue
John Haviland, architect, 1822–1836
National Historic Landmark
National Register of Historic Places
Philadelphia Register of Historic Places
Photographs, 1993

When it opened in 1829, Eastern State Penitentiary was perhaps the first modern building in the United States with both central heating and plumbing. The novel radial and gothic design served as a model for more than three hundred prisons worldwide. It quickly became a must-see destination for visiting dignitaries. On a visit in 1842, Charles Dickens described the conditions as "cruel and wrong," particularly the prison's famous use of solitary confinement, which drove many prisoners insane. In need of serious repairs, the prison was closed in 1971. After twenty-two years of abandonment, the prison came under the management of a preservation group that began to stabilize the ruin. In 1994 the prison opened for tours and eventually became Eastern State Penitentiary Historic Site. Each autumn it transforms itself into a popular Halloween haunted attraction, the proceeds from which help to fund its nonprofit educational programs and exhibitions.

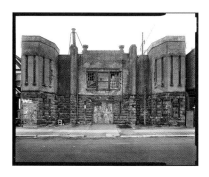

National Guard Patrol, Battery A

4111 Mantua Avenue

A. Green, architect, c. 1892

Photograph, 1997

There is little known about this forgotten armory in the West Philadelphia neighborhood of Mantua. After allowing it to sit unused for decades, the city gifted the property to an out-of-town developer in 2005. Unfortunately, it remains vacant.

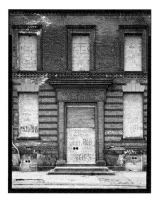

Twenty-sixth District Police Station

2136–2142 East Dauphin Street

John T. Windrim, architect, 1896

National Register of Historic Places

Philadelphia Register of Historic Places

Photograph, 1994

This station house is representative of an important period of reorganization and expansion made by police and fire departments in the last decade of the 19th century. The station remained active until 1952. It was converted into a Police Athletic League center and served in that capacity for twelve years until it was determined the building was too expensive to maintain. It was heavily vandalized after its closure and then sold in 1969 for $6000. From 1969 to 1980 it housed a maker of convenience–store foods for Mrs. Paul's foods. In 2012–13 the building was renovated, converting the first floor for retail use and apartments on the upper floors.

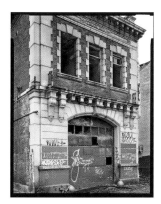

Truck No. 14

2936–2938 Ridge Avenue

Philip H. Johnson, architect, 1904

Demolished, 1994

Photograph, 1994

Closed as a firehouse in 1962 this building lay vacant until 1982 when the Committee for a Better North Philadelphia attempted to convert it into the Strawberry Mansion Community Center. City and corporate grants helped the organization clean up the site. However, community groups organized to fight poverty found themselves impoverished by recession in the early 1980s, a problem compounded by government funding cuts. The station house was soon abandoned again and it was demolished by the city in 1994 after years of complaints from area residents concerning its condition. Councilman John Street invited the neighborhood to plan a post demolition flower/vegetable garden and a "tot lot," but the site has remained vacant and overgrown and was given by the city to a private individual in 2009.

114

Engine Company 13

1529–1539 Parrish Street

Architect unknown, 1901

Photograph, 2001

This station house was closed in 1950 when a new firehouse opened, consolidating three fire companies into one. It is similar to the scores of magnificent firehouses that have been sold, abandoned, or demolished in Philadelphia in the past fifty years. This firehouse was sold by the city in 1982 for $25,000. In 2006 it was converted into a residence.

USS Des Moines CA-134

Inactive Ships Maintenance Facility

Former Philadelphia Naval Shipyard

1946

Photograph, 2005

The last of the classic gun boats, this heavy cruiser was ordered during WWII but wasn't launched until 1946. She served for only thirteen years before being decommissioned in 1961. The ship was stored in the freshwater basin at the Philadelphia Naval Shipyard until 2006. She was unable to attract a museum patron and was scrapped in Texas in 2007.

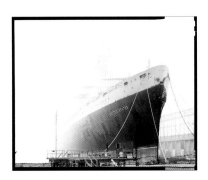

SS United States

Delaware River Pier 82

William Francis Gibbs, architect/engineer, 1952

Photograph, 2006

In the seventeen years this classic ocean liner was in service, it held the transatlantic speed record. Forty-three years after being retired from service, it still holds the westbound record. In 1952 the U.S. government provided two-thirds of the funding for the last ship of its kind to be built in the country, intending to reserve it for troop transport in time of war. The age of the ocean liner came to an end with the close of the 1960s. After being mothballed in Norfolk, Virginia, the ship's furniture and fittings were auctioned off in 1984. It has been moored at Pier 82 on the Delaware River since 1996. A preservation group hopes to refurbish the ship but expects the costs to be approximately $200 million.

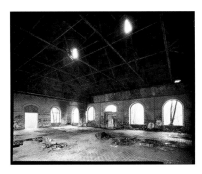

Shawmont Waterworks

Schuylkill River and Shawmont Avenue

Architect unknown, 1869

Demolished, 2011

Photograph, 2005

As with the nearby Shawmont train station, little is recorded about this pumping facility. Completed around 1869 and used for nearly one hundred years, the pumphouse

was abandoned by the Water Department in 1962. The Roxborough Basin, to which this station directed the river's waters, has over the years turned into thirty-eight acres of wetlands. Residents have successfully held developers at bay in the fight to preserve the open space. Until it was demolished in 2011, the old pump was a much visited ruin on the Schuykill River Trail.

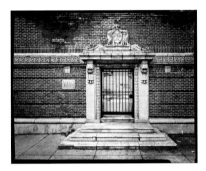

Fante-Leone Public Pool
837–839 Montrose Street Architect unknown, c. 1905
Demolished, 2012
Photograph, 2001
One of the last original public pools built by the city for the most densely populated immigrant neighborhoods, this one served as a popular gathering place for Russian Jews as well as Italians.

In 1990 the name was changed from the Montrose and Darien Street Pool to Fante-Leone to honor two leading figures in the community. The pool was to be part of a million-dollar Italian Market Renaissance Project announced in 1995, but ultimately the pool was excluded from the project. Instead it was closed permanently, and the city sold the property in 2006. After changing hands again, the pool was demolished and a large residential property went up in 2012. City policy has in recent years moved toward the closure of public pools, replacing them with sprinkler fountains in public playgrounds.

Health and Human Services

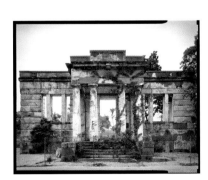

Pennsylvania Hospital for the Insane
44th Street and Market Street
Isaac Holden, Samuel Sloan, Dr. Thomas D. Kirkbride, architects, 1836–1840
Philadelphia Register of Historic Places
Demolished, 1959
Photograph, 1998
This pioneering mental hospital design was surrounded by a 113-acre campus complete with gardens and a miniature amusement railway. The hospital was built at the urging of Dr. Benjamin Rush, a signer of the Declaration of Independence and considered the father of American psychiatry. The facility later became known as Kirkbride's Hospital, after its first superintendent, who instituted a treatment plan that regarded the mentally ill with the same level of consideration as the physically ill. Kirkbride

emphasized the use of sunlight, exercise, privacy, and cultural activities in the treatment of mental illness. Prior treatment and confinement had occurred in the basement of Pennsylvania Hospital, the nation's first hospital, where overcrowding, sedation, and cruelty was the norm. One of the first buildings designated as historic and protected, in 1957, by the recently established Philadelphia Historical Commission, the building was demolished just two years after its designation. The entrance portico and flanking walls were preserved on the site as a compromise with the property's new owners, the Philadelphia Housing Authority, which could find no reuse for the building. For forty-five years it stood as a monument with a bronze historical marker on the grounds of the West Park Public Housing complex until it was considered a hazard and demolished.

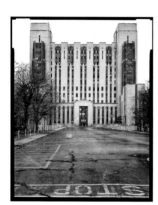

United States Naval Hospital

1400–1889 Pattison Avenue

Livingston Smith and Walter T. Karcher, architects, c. 1932

Demolished, 2001

Photograph, 1998

The first high-rise and campus-enclosed Navy hospital in the U.S., the Naval Hospital housed 1,100 beds and became a pioneer in the advancement of prosthetic limbs. The Navy closed the hospital in 1993 and gave the land and buildings to the city. Unprotected by any historical designations there was only a cursory review of its historic status and potential for reuse before the city demolished the hospital in 2001 to create a 1,500-car parking lot—which it donated to the Philadelphia Eagles and Phillies during a period when the two sports teams were threatening to leave the city.

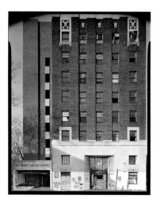

Nicetown-Tioga Health Center

1700–1706 West Tioga Street

Architect unknown, 1927

Photograph, 1998

This former bank, the Tioga Trust Company, and an apartment building were purchased by Temple University Hospital after World War II, and were used as a nurses' residence and administration offices. It was converted into a large community health center in 1969 with funding made available by the Johnson Administration's "War on Poverty" programs. It was part of a quasi public-private plan, which opened several health centers in the city. Financial scandals involving federal funds erupted in the 1980s and led to the closing of this facility. The building remains vacant and is currently owned by a Spokane, Washington, mortgage company.

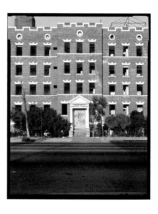

University Medical Center

739 South Broad Street
Ballinger, architect, c. 1926
Demolished, 1995
Photograph, 1993

A for-profit institution, this hospital, originally Women's Southern Homeopathic Hospital and later Broad Street Hospital, began to lose money in 1986 due to lower Medicare-Medicaid reimbursements. The 150-bed facility closed in bankruptcy in 1988. The attached nursing home closed two years later. The building was completely looted; everything was taken, including its windows and copper pipes. It was eventually demolished in 1995.

Philadelphia Child Guidance Clinic

1747 Christian Street
Architect unknown, c. 1890
Photograph, 2005

Originally built as post office Station D in the early 1890s, this building became a branch of the world renowned Child Guidance Clinic in 1974, when the clinic's original site was demolished along with the old Children's Hospital at 18th and Bainbridge Streets. Child Guidance Clinic offered child therapy that was introduced in the 1920s to help combat child delinquency. The practice worked with the parents as well as the child and involved the active participation of a psychiatrist, psychologist, and social worker. This branch closed in the early 1980s because of accusations of financial mismanagement of city funds, racism, and ultimately budget cuts. In 2006 the former clinic building was converted into luxury condominiums.

Former Metropolitan Hospital

Franklin Square, 201–59 South 8th Street
Anthony F. Orefice, architect, 1971
Photograph, 1997

The Metropolitan Hospital was a nonprofit osteopathic institution, which was opened in an existing building in 1944. They built this building in 1971 with the aid of the City of Philadelphia's Redevelopment Authority and the U.S. Department of Housing and Urban Development. In 1989 the hospital filed for bankruptcy. It reopened briefly as the Franklin Square Hospital in 1990 but was sold again in 1992. The next year, after a financing deal fell through, a court order forced the hospital to vacate and seal the building on thirty-six hours notice. The interior of the hospital remained frozen in time for ten years while its exterior overhangs sheltered the homeless. In 2002 it nearly became the Philadelphia Dream Center, a large "supermarket of ministries" that would have housed a large number of human services as well as a Pentecostal church. The project fell through partly due to disagreements with the nearby residents of Chinatown, who

118

rejected the plan and were trying to find a buyer who would convert the building into much-needed senior housing. In 2005 a new owner turned the former hospital into a 130-unit luxury condominium named MetroClub.

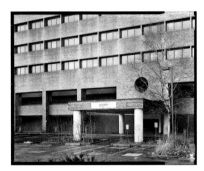

Mount Sinai Hospital
South 5th Street and Reed Street
Magaziner, Eberhard & Harris, architects, 1921–1939
Photograph, 2000

A complex of buildings, Mount Sinai Hospital occupies a full block in the Southwark neighborhood of South Philadelphia. On this site in 1905, the hospital began to fill the growing needs of Jewish immigrants who formed the majority population of this part of South Philadelphia. Its mission was to provide free care to all people. Due to demand, the hospital continually expanded during its first sixty years, with a modern wing (pictured) completed in 1987. A year later, however, the financially troubled institution was sold to Graduate Hospital. In 1996 the 183-bed hospital was purchased by Allegheny Health System, a statewide system of public hospitals. Allegheny laid off five hundred Mt. Sinai employees and closed the facility in 1997. Financial mismanagement and a scandal involving the looting of its endowment led to the bankruptcy of Allegheny. In 2000 the hospital's equipment was sold by court order to pay creditors. Part of the original nursing school now serves as apartments for seniors; most of the former medical facility remains boarded up.

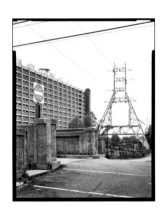

Schuylkill Falls Public Housing
Ridge Avenue and Merrick Street
Oscar Stonorov, architect, 1954–1955
Demolished, 1996
Photograph, 1995

Considered innovative in design when completed in 1955, Schuylkill Falls was terribly flawed. Crime, vandalism, and poor maintenance forced the city to close the projects. In 1976, the two 14-story, 224-unit apartment slabs were sealed shut. They were imploded in December 1996 in the first application of HOPE VI (Housing Opportunities for People Everywhere) grants to Philadelphia. The new federal housing policy essentially ended high-density apartment building. The Department of Housing and Urban Development provided $26 million for the demolition. The Philadelphia Housing Authority partnered with Penrose Property to build 250 new housing units and 17,500 square feet of retail space on the site. Approximately half of the units are rented at market rate while the remainder are subsidized. Fifteen acres of the site are being developed to create independent market-rate housing.

Southwark Plaza Public Housing

4th Street and Washington Avenue

Oscar Stonorov and George Howe, 1963

Demolished, 2000

Photograph, 2000

Southwark Plaza was a three-building high-rise project built by the Philadelphia Housing Authority in 1963, designed by two men who were greatly influenced by the idealist urban planning ideas of Swiss architect Le Corbusier. Like the Schuylkill Falls Housing project, the nightmare effects of concentrating low-income residents in poorly maintained facilities quickly created innumerable problems for tenants and the surrounding neighborhood. In 1996 Congress enacted HOPE VI, which provided cities with over $4.5 billion to redevelop, and in many cases privatize, public housing. In 2000 two of Southwark's towers were demolished with money from this program (one was remodeled) to make way for a private, mixed-income housing project called Riverview Plaza. The Emanuel Evangelical Church adjacent to the site was built in 1868, its massive clock imported from Germany. The congregation abandoned the church in the year leading up to the demolitions. Its interior has been stripped of its contents by a salvage company and the building left a shell. A Buddhist congregation is now struggling to rehabilitate the church as a temple.

University Nursing and Rehabilitation Center

739–751 South Broad Street

Architect unknown, c. 1974

Demolished, 2000

Photograph, 1994

In 1990 this health facility went bankrupt and was closed by the state. A number of staff members were arrested for fraud and theft. The property fills a full block of the "Avenue of the Arts," but remained vacant for nearly a decade after the announcement of this major revitalization project. In 2000 the city's Redevelopment Authority demolished the property and sold the one-acre site to Universal Companies, a local nonprofit developer. The long deadlock over development was broken after the city threatened to take back the property and forced the nonprofit developer to sell its stake in the land. Now the block is host to 777 South Broad, a 146-unit luxury apartment and retail complex, which opened in 2010.

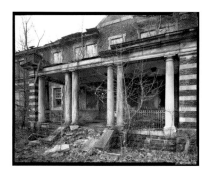

The Philadelphia State Hospital for the Insane at Byberry

14000 Roosevelt Boulevard

Philip H. Johnson, architect, c. 1906

Demolished, 2006

Photograph, 2005

This psychiatric hospital complex (at one time known as the Philadelphia Hospital for Mental Diseases) completed its final expansion in the 1950s to over fifty buildings on its 1,000 acre campus. Its population reached its peak by 1960, when 7,000 patients

were housed here. In 1936 the state took possession of the complex due to complaints about maltreatment of patients. However, conditions did not improve and by the 1980s the hospital had become infamous for patient abuse. At the height of the deinstitutionalization trend, the state put an end to the crisis by closing the campus in 1990. The Philadelphia Industrial Development Corporation acquired the remaining 152 acres of the site in 2004. It sold the property to two large developers who began demolishing all the buildings in 2006 and are constructing 398 residential homes and an office park. A sixth of the park-like campus will be preserved as open space. By 2013 one half of the homes have been completed and sold and the commercial half of the development has not begun.

Education

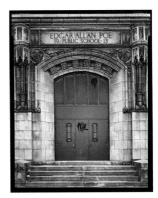

Anthony Wayne Public Elementary School

2700 Morris Street
Henry deCourcy Richards, architect, 1909
National Register of Historic Places
Photograph, 1993

The Board of Education closed this building in 1976 and sold it in 1987 to Geriatric Medical Services. However, the company failed to launch its plans to build a 180-bed nursing home. Over the years, neighbors filed many complaints about the deterioration of the property, and it was cited as a public nuisance. After thirty years of vacancy, apartments for seniors were built in the former school building and opened in 2006. Tax credits, in various forms, made this project possible.

Edgar Allan Poe Public School

2136 Ritner Street
Henry deCourcy Richards, architect, 1913
National Register of Historic Places
Philadelphia Register of Historic Places
Photograph, 1995

In 1979 the Poe Elementary School became the Girard Academic Music Program (GAMP), a magnet public school. This successful academic and music school had begun five years earlier as an alternative program developed at the Stephen Girard School. In a simple example of school reuse, GAMP took over the retired Poe School, whose students were eased into the Girard School.

Spring Garden School Number 1

12th Street and Ogden Street
Irwin T. Catharine, architect, c. 1927
National Register of Historic Places
Photograph, 1998

This school is located near the center of Philadelphia's first public housing project, the Richard Allen Homes. Local crime forced its closing in 1982. Reuse for human services and education was explored, but funds for the projects were too prohibitive. After lying vacant for twenty-seven years, ownership was handed over to the Philadelphia Housing Authority in 2009. The property is still vacant, and no plans have been presented for the building or the site's future.

Board of Education Building

21st Street and Benjamin Franklin Parkway
Irwin T. Catharine, architect, 1932
National Register of Historic Places
Philadelphia Register of Historic Places
Photograph, 1998

For seventy-three years this monument to public education housed Philadelphia's Board of Education. It was part of an ensemble of public buildings at the mid-point of the mile-long Benjamin Franklin Parkway, which itself is one of the finest examples of the City Beautiful movement. On the building's tower are sixteen colossal heads of famous figures from history ranging from William Shakespeare and Isaac Newton to Thomas Jefferson and Thaddeus Stevens. In 1932 scattered administrative offices were consolidated within its walls.

In late 2001, because of a $235 million deficit—due in part to increasingly lower funding from the state—the state legislature voted to abolish the Philadelphia School Board and replace it with a state-controlled School Reform Commission. One of the SRC's first acts was to borrow $300 million. It then proceeded to purchase the 1949 Philadelphia Daily News printing plant, which had been vacant for ten years, for $60 million in 2003. In the fall of 2005, the School Board consolidated its 1,400 administrative staff in the renovated old plant, which had four times the area of the former headquarters. This move ended up costing more than $130 million. In 2012 the SRC borrowed another $300 million to cover its deficit, which had ballooned to over $1 billion dollars. In 2005 the former headquarters building was sold to a developer for $10 million, approximately $45 per square foot. It is not clear the SRC's move to the old Daily News building saved any money, as was hoped.

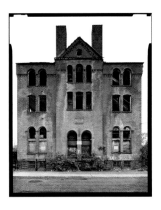

St. Anthony De Padua School

2317–2333 Carpenter Street
Frank R. Watson, architect, 1897
National Register of Historic Places
Photograph, 1998

The Archdiocese of Philadelphia opened this school in the midst of building a city school system to rival the rapidly expanding public school system. Demand for the school, which served grades one through eight, peaked in 1925 with 1,200 students. Declines in enrollment began during the Great Depression; by the 1970s, the archdiocese initiated a policy of school closure and consolidation which continues today. This school was closed in 1986 and sold the following year. In 2000 the building was converted to a retirement facility, whose financial viability depended on various tax credits.

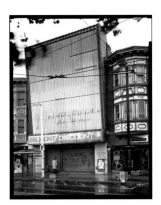

Martin Luther King Jr. Living Memorial

4102–4104 Lancaster Avenue
John D. Allen, architect, 1912
Photograph, 1995

Originally opened as a legitimate theater, the Leader theater was converted to a cinema in the early 1920s and closed in 1969. Donated to the Police Athletic League in 1970, the building was reborn as the Martin Luther King Jr. Living Memorial and became an important part of the community. (In 1965 King addressed a crowd of 10,000, a block from this site.) The center closed in the mid 1980s, but the modern facade treatment, installed in 1971 by PAL, remains. It has served as a discount variety store since 1987.

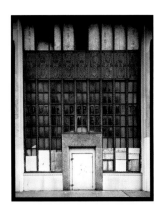

Youth Opportunity Center

1221 North Broad Street
Architect unknown, 1928
Photograph, 1997

This former North Broad Street Trust Company building became one of 105 centers opened nationally by the U.S. Department of Labor under the Johnson Administration's "War on Poverty" program. There were three centers in Philadelphia. This one opened in 1966 with great fanfare after a $100,000 renovation. Young people ages sixteen to twenty-two were referred to the center by area schools, Selective Service boards, and other groups engaged with youth and trained and placed in a variety of positions. The program also provided an occupational library, counseling, medical, dental and other social services. Left abandoned for decades, it became a self-storage center in 2006.

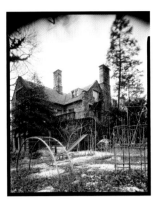

Parkgate

6340 Wayne Avenue
Durhring, Okie & Ziegler, architects, 1899
Photograph, 1994

Donated to the School District of Philadelphia in 1954, this stately home was built for John D. McIlhenny, the first president of the Philadelphia Museum of Art, on a rise above Lincoln Drive. Sited near a notable entrance to Fairmount Park (as the name implies), the house was surrounded by large formal gardens. It was a center of cultural activity during the rise of the Modern era in painting, and housed many works by masters of French Impressionism. After McIlhenny's death in 1925, many of the paintings were given to the art museum but the house remained the residence of McIlhenny's son, Henry, until 1950. Henry McIlhenny developed a very impressive art collection of his own and was a curator and chairman of the board at the Philadelphia Museum of Art.

In 1956 a new school building was constructed on the nine-acre property. The formal gardens and stables were paved over for parking. In the 1980s, during a wave of city building closures due to the discovery of asbestos, the mansion was sealed. It has remained closed since, but break-ins and vandalism have damaged much of its interior. Its prominent placement on Lincoln Drive is now hidden from view by dense woods.

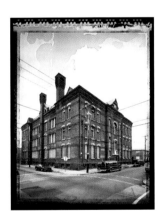

Francis M. Drexel School

1800 South 16th Street
Joseph W. Anschutz, architect, 1888
National Register of Historic Places
Demolished, 2010
Photograph, 2000

The Drexel School was one of seventy-five school buildings designed for the city by Anschutz. Most were built in the High Style Victorian mode. Anthony Drexel, son of Francis M. Drexel, financed the school as well scores of others in Philadelphia, including most famously Drexel University. In 1986 the school board sold the building, which had been closed for several years. Due to problems with asbestos removal, the building became an EPA Superfund site in the mid 1990s. It was demolished in 2010 to make way for a future housing development yet to break ground.

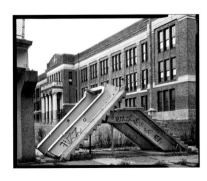

Charles Y. Audenried High School

1601 South 33rd Street
Irwin T. Catharine, architect, 1930
National Register of Historic Places
Demolished, 2006
Photograph, 1996

This high school, the worst performing in the city, was well known for its violence and racial strife, and earned the nickname "prison on the hill." It was closed in 2005 and

demolished a year later. A new $60 million school building was built on the site and opened in 2008. However, the violence continues at the new school, although now equipped with hi-tech surveillance and security features. Parts of the school have been closed off due to low enrollment and the inability to provide safety. In 2011 the school operation was turned over to a charter school company despite strong objection by the community and the failing record of the charter company. The deciding factor for the School District was the charter's success in attracting federal and foundation grants.

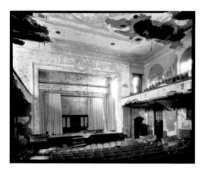

Cheltenham High School

Montgomery Avenue and High School Road, Elkins Park, PA
Davis, Dunlap & Barney, architects, 1925
Demolished, 1994
Photograph, 1994

Operated from 1926 until 1977 as Cheltenham High School, this building was sold and then reopened as the private Beth Jacob School. Beth Jacob was abandoned in the late 1980s, and the building was destroyed by fire in 1994. The land is now preserved as a public park.

Commerce

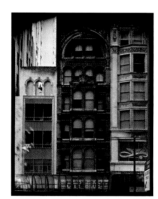

The Gibson Building and adjacent buildings

1301–1319 Market Street
Hewitt Brothers, architects, c. 1897
Demolished, 1994
Photograph, 1994

One of the last remaining contiguous 19th-century commercial blocks on Market Street, the Gibson building and its neighbors contained theaters, eateries, garment manufacturers, and Allinger's Billiard Academy. The block of buildings was acquired in the 1970s by Samuel Rappaport, and a sleek remodel of the block was proclaimed. The Philadelphia Industrial Development Corporation awarded low interest loans to Rappaport to complete his purchase of the block. But Rappaport was not a developer. His formula was to profit from decline. At his peak in the early 1990s, Rappaport owned sixty buildings in Center City, all with outstanding city code violations. He brought great attention to the tactic of "demolition by neglect," a practice aimed at circumventing legislation to protect historic buildings or attracting public assistance. The city forced Rappaport to demolish the block due to its proximity to the Pennsylvania Convention Center and the new Marriott Hotel. This site was converted to a surface parking lot in 1995, contravening a city zoning ordinance prohibiting surface lots in this area. At the lower right of the photograph, a window can be seen that was decorated for the filming of the 1981 movie *Blow Out*, directed by Brian De Palma and starring John Travolta.

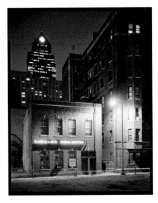

Oliver Bair Funeral Home and Warwick Apartments

1906–1920 Sansom Street
Philadelphia Register of Historic Places
Photograph, 1997

After a fire destroyed several buildings adjacent to Rittenhouse Square in 1994, a developer "packaged" the newly vacant lots together with these two buildings and a third building that once housed the Second Fret Coffeehouse, famous in the early 60s for its live blues and folk music. A few months later, the group was sold to the Philadelphia Parking Authority. Immediate plans to demolish the historically listed buildings resulted in the eviction of all tenants and the closure of the largest affordable apartment building in the Rittenhouse Square district. The Parking Authority sought to build a six-hundred-car garage on the site, though such a use was prohibited under the city's zoning laws. Although the rezoning was eventually approved for the project, the Preservation Alliance went to court and successfully defeated the demolition plan.

In 2007 the Parking Authority sold the site and buildings for $36.7 million to Castleway Developments (an Irish developer), at a profit of $31 million. The owners subsequently went bankrupt and still owe the city more than a million dollars in back taxes, and no development has taken place or is planned for the site to date.

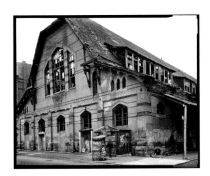

Ridge Avenue Farmers' Market

1810–1818 Ridge Avenue
Davis E. Supplee, architect, 1875
National Register of Historic Places
Philadelphia Register of Historic Places
Demolished, 1997
Photograph, 1995

This 40,000-square-foot market was farmer owned and operated for nearly a century until its sale in 1967. The building incorporated the latest in engineering advancements to create a remarkable open plan with soaring ceilings and much natural light. In 1968 new owners converted the building to a discount clothing and household goods store. It closed permanently in 1972. In 1983 a developer from the neighborhood purchased the property and tried to revive the market, which was arguably the heart of the old commercial center of Francisville where Girard and Ridge Avenues intersect. The developer claimed that disputes with the city made it impossible for him to proceed with the $1.5 million project. After storm damage caused a partial collapse of the building, the city ordered the long-abandoned market demolished in 1997. An outdoor seasonal farmers' market did eventually appear across from the site in 2001. The market was a beautiful piece of architectural history, and demonstrated the important role such a building can play in the economic and nutritional well-being of a neighborhood. Its loss was considerable.

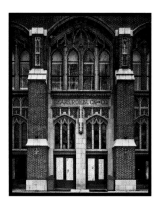

Sears, Roebuck & Company

Roosevelt Boulevard

George C. Nimmons, architect, 1919–1920

Gold Medal, Philadelphia Chapter, AIA

Demolished, 1994

Photograph, 1994

When it was completed, this Sears distribution complex and office building was the largest reinforced-concrete commercial structure in the world. Situated at a major bend in Roosevelt Boulevard, it was a principal landmark for this northeast section of the city. Operations in the building ended in 1993. Because of the size of the building and its lack of any official landmark status, it was brought down by implosion in 1994. Local media reported the spectacle, revealing the onlookers' deep emotional response to the loss: Where the imposing building once stood, a parking lot now serves a shopping center development.

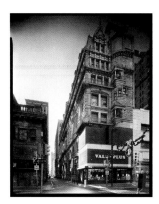

The Hale Building

Chestnut Street and Juniper Street

Willis G. Hale, architect, 1887

Philadelphia Register of Historic Places

Photograph, 1994

The Hale building allows an observer to imagine the streetscape of Chestnut Street at the zenith of the Gilded Age. The former Keystone National Bank Building changed its name in 1895 after fraud indictments ruined the bank. The building survived the bank's failure and continued as a successful office building. Like much of the street-level architecture on Chestnut, the architecture of the Hale Building was considered in bad taste during the 1950s. Its facade was resurfaced with modern commercial treatments when it became a shoe store. It then became a dollar store, as pictured here, but the site has been vacant since 2010, when a developer signed an agreement to purchase the building to convert it to a boutique hotel. However, he was unable to obtain financing, and the project seems to have been abandoned.

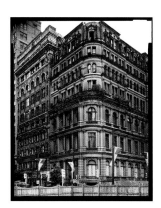

The Victory Building

Chestnut Street and 10th Street

Henry Fernbach, architect, 1873–1890

Phillip Roos, architect (West Building), 1895–1901

National Register of Historic Places

Philadelphia Register of Historic Places

Photograph, 1993

One of Philadelphia's first office buildings and the only surviving example in the city of the Second Empire style used in a commercial building, the Victory was originally built as a branch of the New York Life Insurance Company, which expanded the main building in 1890 and added the Renaissance Revival style annex in 1901. Samuel Rappaport,

Philadelphia real estate speculator, purchased the building in 1974. By 1982 the lack of maintenance and a fire had driven out most of the tenants. Over the next ten years, the building was repeatedly vandalized leaving it degraded and at risk. In 1993 Rappaport received a demolition permit, which triggered the Preservation Coalition (predecessor to the Alliance) to take out a full page ad in the Inquirer asking the public to fax Mayor Ed Rendell (before email) opposing it. Rendell's office was so overwhelmed with faxes that the mayor backed off and the building was saved. After Rappaport's death in 1994, the building was sealed and subsequently sold. It became a condominium development in 2005.

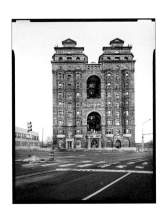

The Divine Lorraine Hotel
Broad Street at Fairmount Avenue and Girard Avenue
Willis G. Hale, architect, 1894
National Register of Historic Places
Philadelphia Register of Historic Places
Photograph, 2005

One of the first luxury high-rise apartment buildings in the city, the Lorraine Apartments anchored the southernmost stretch of high-society residences on North Broad Street. The luxury boom of North Broad Street began to wane in the early 20th century. By the time of the Great Depression, the area had become predominately black and Jewish, and the Lorraine was transformed into a hotel. The Universal Peace Mission Movement of Father Divine purchased it in 1948, and it became one of the first integrated first-class hotels in the United States.

In 2000, a New York historic property developer, Tony Goldman, purchased the hotel for $1.9 million from the followers of Father Divine and the hotel was closed. His plans for the building were scuttled with the onset of the recession in 2001, and the building—still in immaculate condition—and adjacent land were sold for $5.8 million to Eric Blumenfeld. In 2006, the Lorraine changed hands again when Blumenfeld sold it to Dutch developers for $10.1 million. The new owners reneged on their condominium conversion plan and had the building's ornate interior stripped and sold as architectural salvage. After losing its luxurious interior and windows, the building was left open to the elements until the city sealed its lower floors. In 2012, with a mortgage and liens totaling over $8 million, the hotel sold at sheriff's sale back to local developer Blumenfeld who is planning 125 loft apartments and a restaurant in this landmark.

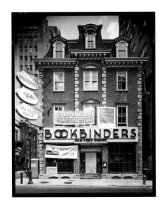

Bookbinders Seafood House, Former 5th District Police Station
215 South 15th Street
Architect unknown, 1870
Philadelphia Register of Historic Places
Photograph, 2005

This Station house was decommissioned in 1924 and sold at auction for $355,000 in 1926. It is likely the oldest existent police building in the city. Bookbinders, founded as

an oyster bar on 5th Street in 1893, was a famous restaurant name in Philadelphia for most of the 20th century. Two members of the Bookbinder family opened a restaurant here in 1935. Declining attendance and family financial disputes lead to its closure in 2004. The building now houses an Applebee's restaurant.

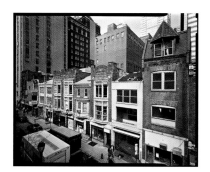

1600 block of Sansom Street
Philadelphia Register of Historic Places
Demolished, 2000
Photograph, 2000

Once a charming ensemble of small shops, restaurants, and apartments which together made up a signature 19th-century Philadelphia side street. This group of buildings on the north side of Sansom, which were part of a National Historic District, suffered twenty years of neglect and scores of uncorrected code violations when owned by real estate speculator Samuel Rappaport. When the new owner of the block, who was also the chairman of the city's Historical Commission, filed for a demolition permit to build a parking garage on the site, the Center City Residents Association, the Foundation for Architecture, and the Preservation Alliance for Greater Philadelphia protested in favor of saving the buildings. However, they were demolished in 2000. When garage plans for the site could not be worked out, the owner—who had been appointed Chairman of the Pennsylvania Historical and Museum Commission in 2004—was given approval in 2005 for a surface parking lot. A new mid-rise apartment building took its place in 2013.

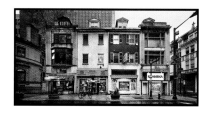

"Rindelaub's Row"
126–132 South 18th Street
Philadelphia Register of Historic Places
Demolished, 2006
Photograph, 2005

Known as Rindelaub's Row, after the bakery that had occupied one of the four buildings in the group since 1928, these buildings were placed on Philadelphia's historic register in 1995. Local street signs designate the block the "French Quarter" to draw attention to its charming, village-like string of shops, bakeries, and cafes. Although the block had always been commercially successful, the owner/developer evicted the tenants in order to demolish the buildings and make way for a thirty-story condominium and retail project. Despite a Historical Commission ruling a year earlier strictly prohibiting even minor alterations to one of the buildings, the developer was permitted to demolish the row of buildings in 2006.

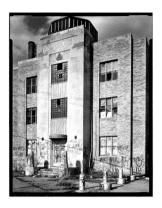

C. Schmidt & Sons Brewery

North 2nd Street and Edwards Street

Otto Charles Wolf, architect, 1914

Demolished, 2002

Photograph, 1994

C. Schmidt & Sons was the largest brewery in Pennsylvania when it closed in 1987 after 127 years of operations. Its fourteen-acre campus held more than fifty buildings and employed 1,400 people. After it closed, the property and surrounding neighborhood deteriorated. In 2000 the site was sold for $1.8 million to developer Bart Blatstein, who demolished all of the buildings in the face of strong local opposition, and for seven years battled with the neighbors over plans for the site's development. During this process, Blatstein transformed the project from a suburban-style strip mall to a more attractive urban project. The result is The Piazza at Schmidt's, a public square surrounded by small boutique businesses, restaurants, and galleries, loft apartments, and stylish town homes. The area is now a very desirable neighborhood.

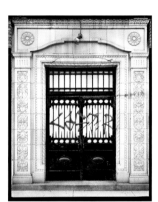

U.S. Bank Note Company

128–140 South 55th Street

Clarence Edmond Wunder, architect, 1925

Photograph, 1999

This now-defunct printing plant was among hundreds in Philadelphia. National commercial printing and publishing industries flourished in the city during the 19th and early 20th centuries. Competition and technological improvements led to greater and greater consolidation and cost cutting. The city's once vast printing industry is now represented only by its attractive shells—archeological signposts. Some have found new uses as residential and artists' lofts, although the U.S. Bank Note Company is currently a self-storage business.

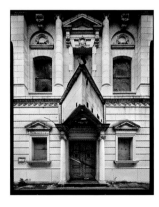

Industrial Trust, Title and Savings Bank

1942–1958 North Front Street

Architect unknown, c. 1900

Photograph, 2002

For decades, this former bank building, originally organized to support the textile industry, has remained empty along with its neighbor the Ninth National Bank. In 1989, the banks were donated to the Norris Square Civic Association by the last owner of the bank, which had changed hands multiple times since the original bank's closure in 1953. In the mid 1990s, the Association—with the assistance of the federally funded Philadelphia Empowerment Zone—began planning to renovate the building for use as a Latino farmers market. The market project never went forward, despite much local support.

It appeared that city and federal funding and local foundation support was more focused five blocks away on construction of a new shopping center, where an entire city

block of commercial and residential properties was cleared. This project required the razing of a dozen homes and the unusual rerouting of historic Germantown Avenue through the shopping center's 150-car parking lot. In 2010 the former bank property was sold to the Women's Community Revitalization Project, which hopes to tear down the ruined banks and build an apartment building with twenty-five units. However, the neighbors' fondness for the landmark corner property and opposition to the zoning changes required for WCRP's project have kept the site unchanged for now.

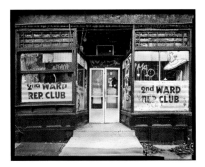

Second Ward Republican Club

707 South 7th Street
Demolished, 2008
Photograph, 2005

This old storefront was transformed into a local base for the Republican Party by Charles Santore, whose parents operated it as a candy store during the first half of the 20th century. Santore, the ward leader until his death in 2002, also founded the Municipal Employees Union Local 696. He was born in the house in 1910. Although founded in Philadelphia, the Republican Party has been out of power in the city since 1952. This building and the ones on either side were torn down in 2008; new townhouses now occupy the site.

Philadelphia once held thousands of "mom & pop" businesses serving the needs of local residents. Nearly every intersection in dense neighborhoods had at least one business—if not four—occupying its corners.

The Delong Building

1232 Chestnut Street
Horace Trumbauer, architect, c. 1900
Photograph, 1994

This corner offers a representation of the commercial character of the heart of the Center City business district in the early 1990s: a mix of lower-end or vacant retail and older office buildings. 1232 Chestnut Street is named after Frank Delong, an inventor who patented an important improvement in the hook-and-eye fastener. The building housed his women's accessory business and a variety of other small businesses. Continuously occupied until the mid 1970s, the building's owner converted the lobby into retail space in 1978, blocking access to the upper floors, which then remained vacant for a quarter-century.

Encouraged by feasibility studies for historic rehabilitation commissioned by the Philadelphia Center City District, 13th Street became the target of New York developer Tony Goldman. Goldman's previous successes were the revitalization and transformation of Manhattan's SoHo district and Miami's Art Deco era South Beach. In 1998, he began by purchasing twenty-five rundown buildings in Center City, concentrating on 13th Street, which was notorious for its seediness. Goldman capitalized on identifying undervalued, walkable, architecturally rich districts hampered by poor quality of life,

and producing commercial developments that exude a sense of authenticity that developers and marketers covet but rarely are able to deliver. This element of authenticity was intensified further by eschewing chain stores and opting instead for boutiques and attracting promising young chefs and restaurateurs. Today the Delong Building houses a trendy cafe and grocery at street level and luxury apartments on the upper floors.

Transportation

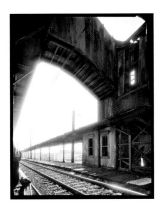

52nd Street Station

52nd Street and Merion Avenue
Architect unknown, 1910
Demolished
Photograph, 1995

This station was constructed at the junction of the Pennsylvania Railroad's Main Line and its Schuylkill branch in 1910 when the section of West Philadelphia it served was rapidly expanding its industrial and residential base. Decades of deferred maintenance and declining service led to its demise. The station closed in 1980. Situated between a densely populated neighborhood and Fairmount Park, this elevated station was only a short walk to the popular Mann Music Center. The station was taken down in a wave of demolitions financed by the Federal Empowerment and State Enterprise Zones, which have put tens of millions of dollars into demolitions in the area since the mid 1990s. The local neighborhood association petitioned the city to help it replace the station, as was originally promised before its removal. Instead, a suburban developer, with large financial assistance from public funds, created a thirty-acre shopping center that includes a 1,000-car parking lot adjacent to the former station. (See United States Post Office, West Park Station, p. 111 above.)

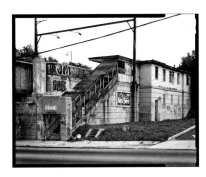

Allegheny Station

Allegheny Avenue and 22nd Street
Photograph, 1995

Although this station looks abandoned in the photograph, it remains in service as part of the SEPTA Norristown line. The station has since been fully renovated—a common pattern since the SEPTA takeover of the city's railroads: Maintenance is deferred for years, decades, or until the station becomes a danger, at which point a substantial state or federal grant is pursued for major renovations or replacement. If ridership has declined substantially in this interim period of neglect, a station may be closed.

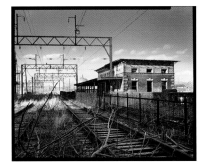

Spring Garden Station and Reading Railroad Viaduct

Spring Garden Street and 8th Street

Photograph, 1994

This was the last stop before the line's terminus at Reading Terminal. The station was closed in 1984, and both the station and the viaduct remain abandoned. In 2003 residents created a group called the Reading Viaduct Project to press the city to transform the monumental viaduct into a greenway park—as was done with New York City's High Line park. After nine years of lobbying from local residents and supporters, a commitment from the city to help transform a portion of the viaduct came through in 2012. It is hoped that the beginnings of this promising park will blossom in 2014.

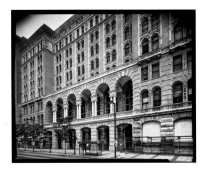

Reading Terminal Head House

1115–1141 Market Street

F. H. Kimball, Joseph Wilson, architects, 1891–1893

National Historic Landmark

National Register of Historic Places

Philadelphia Register of Historic Places

Photograph, 1995

The Reading Terminal marked the peak of architecture and engineering for the Philadelphia and Reading Railroad. It was for a brief time the largest single-span arched train shed in the world. The Reading Railroad's business began to decline in the post–World War II period, when the nation initiated a transition from coal to liquid fuels. While transporting coal was the heart of the Reading's business, its passenger service was also crippled by the advent of widespread automobile ownership. All the great railroads in the country saw their revenues decline in the decades after the war. The Reading Railroad went into bankruptcy in 1971. Its freight services became part of Conrail while it passenger service was taken over by SEPTA, which last used the terminal station in 1984. The last of its once-great real estate holdings, the Head House, was sold to the city in 1993. This photograph shows the Head House shortly after its 1948 modernizing treatments were removed. The terminal's head house and shed were rededicated after a major restoration in 2001 to become part of the Pennsylvania Convention Center.

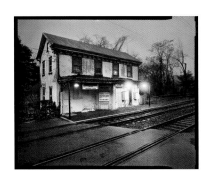

Shawmont Station

Nixon Street and Shawmont Avenue

Architect, William Strickland (attributed)

Philadelphia Register of Historic Places

Photograph, 2004

Built in 1834, Shawmont Station is the oldest passenger railroad station in the U.S. and perhaps the only one remaining in the Greek Revival style. Originally built by the Philadelphia, Germantown and Norristown Railroad it later became part of the Reading Railroad. The building then served as a SEPTA regional rail station until 1990.

After a short period of flag service where riders signaled with their arm for an engineer to stop, it was closed permanently in 1996. Through the efforts of a neighborhood historian, the station was given a historic designation by the city in 2008. However, in the years since, no matching effort by either SEPTA, city, or state officials has been made to maintain or restore the station.

North Philadelphia Station

North Broad Street and Lehigh Avenue
Theophilus P. Chandler, architect, 1901
National Register of Historic Buildings
Photograph, 1994

This Beaux Arts station was built by the Pennsylvania Railroad when it was one of the largest and most powerful companies in the U.S. Now the station is the oldest remaining station on the nation's North East Corridor. Amtrak took control of what became of the "Pennsy" after bankruptcy, restructuring, and the eventual government takeover of its passenger service in 1976. In 1983 Amtrak took control of the station. By 1990 the original station, once thought of as the classiest in the city, had been abandoned. However, SEPTA regional rail trains continued to stop here, and a small ticket office was placed in the parking lot. In 2001 that ticket office closed. After fifteen years of public announcements of redevelopment attempts by Amtrak and local politicians, a deal was announced with a developer to convert the station to commercial use. A large part of the historic station was demolished, and the station and its surrounds became part of a joint public-private investment of $18 million to produce a shopping center anchored by a Pathmark supermarket that opened in 2002. The main section of the station (pictured) is now a budget furniture store.

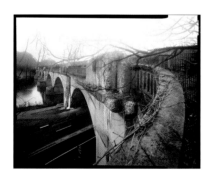

Columbia Bridge

Fairmount Park
1920
Photograph, 1997

Built by the State of Pennsylvania as part of the Philadelphia and Columbia Railroad, the Columbia Bridge was the first railroad crossing of the Schuylkill River. Later it was sold to the Reading Railroad, which replaced the original with a wrought iron bridge. In 1920 it was replaced with this reinforced concrete bridge, which now belongs to Conrail. The heft of its structure has allowed a lengthy maintenance-free period of service for the bridge, which despite daily traffic has sprouted many trees and other natural features since coming under Conrail's care.

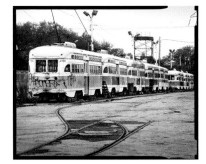

SEPTA Luzerne Depot Trolley Yard

1000–1100 West Luzerne Street

Architect unknown, 1913

Photograph, 2002

The Luzerne Trolley Depot, built in 1913, ceased operations in 1992. In 1997 it was closed permanently and is currently a cardboard recycling warehouse. The depot was built by the Philadelphia Rapid Transit Company during the peak of expansion of the city's streetcar system. The city was crisscrossed by trolley routes, with nearly every block in the city served. In 1934 during the Depression, the system went into bankruptcy and reemerged in 1940 as the Philadelphia Transportation Company. In 1955 a holding company, National City Lines set up by General Motors, Firestone, and Standard Oil, purchased the PTC, adding it to there collection of more than one hundred streetcar systems. Most of these systems were dismantled and replaced with GM buses. Philadelphia's streetcar system quickly lost 73 percent of its trolley routes. In 1968, while once again swamped in bankruptcy, the transit company was taken over by SEPTA, a quasi-public agency. During these troubled years, thousands of trolley cars were scrapped and many dozens sold. Cities such as San Francisco, New Orleans, Denver, and Portland, Oregon, have put Philadelphia's former streetcars into service in efforts to establish or revitalize heritage streetcar lines.

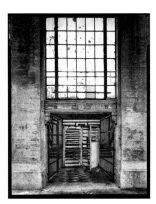

Berks Station, Frankford Elevated

Department of City Transit

1900 Front Street

William Howard Lee, architect, 1915–1922

Demolished c. 2000

Photograph, 1998

The Frankford Elevated line was opened in 1922 and helped lift the northeastern section of Philadelphia to its industrial peak. Each of the original stations on the line featured a different Art Deco motif. Vandalism and lack of maintenance did much to damage the stations over the years since 1968 after SEPTA took control of the Philadelphia Transportation Company, the largest urban transit company in the world still in private ownership. This station and the ten other elevated stations were replaced between 2000 and 2005 with new more accessible stations that use maintenance-free materials like plastics, stainless steel, and ceramic tile.

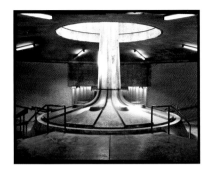

City Hall Transit Concourse

Photograph, 1993

This underground commuter concourse was constructed in the mid 1970s by the Pennsylvania Railroad on several blocks of property just west of City Hall. Penn Center was created in close cooperation with the Philadelphia City Planning Commission under the leadership of Edmund Bacon. The plan produced more compromises than achievements. The underground transit concourse, which connects Penn Center and City Hall with the city's hub of transit lines is intimidating and dimly lit. In 2012 the city began demolishing parts of the concourse for a $50 million remodeling of Dilworth Plaza.

Culture

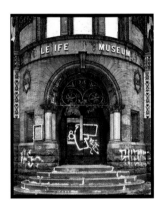

Ile Ife Museum of Afro-American Culture

Germantown Avenue and Dauphin Street
Walter D. Smedley, architect, 1893
Philadelphia Register of Historic Places
National Register of Historic Places
Demolished, 1997
Photograph, 1994

From 1972 to 1988 the Ile Ife Museum was housed in this former Northern National Bank building. The museum was founded by pioneering choreographer Arthur Hall and was the first African-American museum in Pennsylvania. Its collection traced the creative expression of West African culture in its transition into contemporary Afro-American arts. In the Yoruba language "Ile Ife" means "House of Love." Lacking the funds to operate, and delinquent on taxes to the city, the museum closed in 1989; much of the collection was lost to theft. During its years of abandonment, thieves stripped the ornate building of its ironwork, tiles, and stone detailing. The site is now a vacant parcel of land.

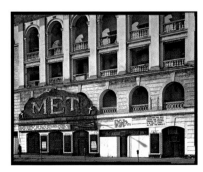

The Metropolitan Opera House

North Broad Street and Poplar Street
William H. McElfatrick, architect, 1908
National Register of Historic Places
Philadelphia Register of Historic Places
Photograph, 1993

This theater, estimated to hold over 4,000 seats, was built by Oscar Hammerstein I for the Philadelphia Opera Company and sold in 1910 to the Metropolitan Opera of New York. It served the Metropolitan as well as many other opera companies until 1938. From the 1930s through the 1950s, the theater provided space for a variety of uses from cinema to sports events. In 1954 it became the Met Church where faith healing services

for thousands were held and were part of a weekly telecast. In 1979 "The Met" began hosting recording sessions for the Philadelphia Orchestra, which cherished the theater's near perfect acoustics. Financial problems forced the church to relocate in 1990. The ruin of the theater served as a set for the film Twelve Monkeys (1995). The city condemned the crumbling theater, but it was purchased in 1996 by another church, which made stabilizing and restoring the space part of their mission. Today the lower-level auditorium is used for services. The church continues to seek funds and partners to restore the Met to its former grandeur.

The Royal Theater

1524–1534 South Street
Frank E. Hahn, architect, 1919
National Register of Historic Places
Philadelphia Register of Historic Places
Photograph, 1993

This black-owned theater became a center of African-American culture in the city. It was also the home of the Colored Motion Picture Operators Union. The Royal hosted musical talent ranging from Fats Waller playing organ accompaniment for silent movies to performances by Pearl Bailey and Bessie Smith. The theater closed in 1970 and was sold at sheriff's auction for $13,700 in 1975 following a long period when the whole neighborhood was threatened by a crosstown expressway project that didn't materialize. The landlord did little to save the building and was cited by the city for demolition by neglect in 1998, forcing him to sell the building. The Preservation Alliance of Greater Philadelphia purchased the theater with its own and city funds and later sold it in 2000 to Universal Companies, which promised to restore the theater and develop an entertainment facility. Besides gutting and sealing the property in 2002, Universal took no other action to reopen the theater.

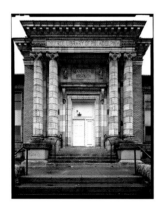

Manayunk Branch of the Free Library

Fleming St. and Dupont St.
Benjamin Rush Stevens, architect, 1906
Photograph, 2000

One of the twenty-five libraries built in Philadelphia from a grant made by Andrew Carnegie in 1903, maintenance concerns forced this library to close in 1961. (Under the agreement signed by Philadelphia in 1904 with Carnegie, maintenance was to be guaranteed by the city through a tax levy.) The building became part of a neighboring nursing home, which used the original entrance as an emergency exit. The nursing home closed in 2006, and the former library was sold to a developer. Strong objections from neighbors prevented the proposed demolition of the building. In 2012 newly constructed homes now crowd and dwarf the once noble building. Seventeen Carnegie libraries remain in use as part of the Philadelphia Free Library system.

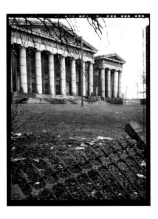

Ridgway Library

901–933 South Broad Street

Addison Hutton, architect, 1873–1878

Philadelphia Register of Historic Places

Photograph, 1993

Organized in 1731 by Benjamin Franklin, the Library Company was America's first subscription lending library. Ridgway Library was built as a "branch," but expansion of the city center southward as predicted by the building's benefactors never materialized, and Ridgway was used primarily as a storage site. In 1964 the Library Company moved out of the building and into a new building close to their original Center City location. In 1973 Ridgeway's basement was converted into a city recreation center, but the main part of the building was abandoned. In 1997, after a $30 million renovation, the building reopened with an addition as the new home of the High School for Creative and Performing Arts.

George Institute Branch of the Free Library

1459 North 52nd Street

E. A. Wilson, architect, 1914

Photograph, 2005

This library was closed for renovations, and a large banner announcing "Big Changes" was hung on the facade in 2002. Despite the state's having earmarked $113,000 for its upgrades, the branch has remained vacant since then. The library system's website continues to announce a reopening date of June 2004. The Free Library sold the branch to a national property holding company in 2011 for $35,000.

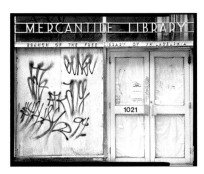

Mercantile Library

Branch of the Philadelphia Free Library

1021 Chestnut Street

Sidney Martin, architect, 1953

National Register of Historic Places

Philadelphia Register of Historic Places

Gold Medal, Philadelphia Chapter, AIA (1954)

Photograph, 1994

Founded in 1822, the Mercantile Library was the premier business research library in the city's commercial district. It merged with the Free Library of Philadelphia, which then opened this branch a block away from its original home. One of the city's most important branches and the only library branch to serve the eastern half of Center City, it was extensively used by the business community. The discovery of deteriorating asbestos led to its closing in 1989 for remediation. However, the branch never reopened, and the area was left without a public library for more than a decade. In 2007 the building was sold to a real estate developer and then resold in 2011. Neglect has, in effect, demolished it.

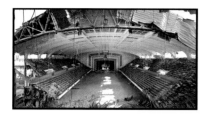

Convention Hall

South 34th Street and Civic Center Boulevard

Philip H. Johnson, architect, 1929–1931

Demolished, 2005

Photograph, 2005

Convention Hall played host to five national political conventions, which included the nominations of Franklin Roosevelt and Harry Truman. The Beatles, Martin Luther King Jr., Pope John Paul II, and Nelson Mandela also made appearances here. It was in this space that the Philadelphia Warriors and 76ers contributed to the rise of professional basketball in Philadelphia. Unprotected by any historical designation, the 13,500-seat Art Deco building was demolished in 2005 shortly after being sold by the city to the University of Pennsylvania. Its splendid sculptural friezes and architectural details were salvaged by speculators and sold, some on eBay. Today on the site stands the Translational Research Center at Penn designed by architect Rafael Viñoly.

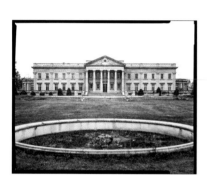

Lynnwood Hall

920 Spring Avenue, Cheltenham, PA

Horace Trumbauer, architect, 1898–1900

Jacques Greber, landscape architect

Photograph, 1994

Situated less than a mile outside the city limits, Lynnwood Hall is a 110-room mansion built by Peter A. B. Widener which housed his family and his extraordinary collection of paintings and decorative arts. Widener founded the Philadelphia Traction Company and built a national streetcar and financial empire. Modeled after Prior Park in Bath, England, the house was originally surrounded by over four hundred acres of land and set amid thirty acres of formal French gardens. Widener, one of the first to press for a new city art museum, had agreed to donate his famed art collection to the City of Philadelphia with the understanding that it would build a new museum, but disagreements among city leaders led to a nearly two-decade delay. Frustrated, Widener built his own "museum and gardens," which he opened to the public. Widener's collection eventually was bequeathed by his son in 1942 to the newly opened National Gallery in Washington, D.C. These six hundred works of art became a principal contribution to the foundation of the nation's first museum of art. In 1952 the mansion was purchased by Faith Theological Seminary. The buildings and grounds have been poorly maintained over the past sixty years, and much of the opulent architectural details and garden statuary were stripped by the owners to pay the mortgage in the 1990s. It is currently owned by the First Korean Church of New York, which has been locked in a dispute with the township for more than a decade over the property's nonprofit status. In 2012 the church was denied tax exempt status, and the future of the church and mansion are in limbo.

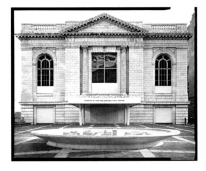

The Commercial Museum

South 34th Street and Civic Center Boulevard

Hewitt Brothers & Wilson Brothers, architects, 1897

Demolished, 2004

Photograph, 1997

This Beaux Arts building was once the internationally recognized Commercial Museum—originally three linked exhibition halls built for the National Export Exposition of 1899, which also served as the museum's grand opening. The collections contained contributions from most of the world's fairs from 1893 to 1940, as well as from the rich industrial past of Philadelphia. Besides storing the treasures from the great age of world's fairs, its leading mission was to provide an active venue for scholarly, economic, and commercial research. The museum also briefly functioned as the country's first international trade bureau before the U.S. Department of Commerce was organized in 1903. After a major renovation, the museum reopened, renamed as the Museum of the Philadelphia Civic Center, in 1958. Major cultural exhibitions were popularly attended, but funding and attendance fell off during the 1970s. Research scholars continued to come from around the world to use the museum's extensive library, and it was a popular destination for school groups even after the museum was closed to the public in 1982. The Philadelphia School Board maintained two instructors on the staff from the 1920s until it closed in 1994. It was the oldest museum educational program in the country. It is estimated that after it was shuttered under the Rendell administration, tens of millions of dollars worth of treasures were looted from the collections, which had no inventory or catalog or staff to manage it. In 2001 the remaining collections were dispersed to local institutions through the city's Orphans' Court. In 2004 the building was demolished after it was sold to the University of Pennsylvania. In its place the Perelman Center for Advanced Medicine now stands.

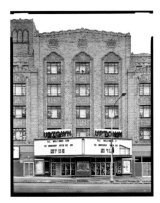

The Uptown Theater

North Broad Street and Susquehanna Avenue

Louis Magaziner, architect, 1929

National Register of Historic Places

Philadelphia Register of Historic Places

Photograph, 1995

Originally opened as a movie palace, its architect had brought in Emil Berliner, inventor of the phonograph and also of the acoustical tile, to assist with the sound quality of the hall. By 1951, the Uptown had become the area's principal rhythm and blues concert hall, attracting audiences of more than 2,200. It was dubbed "the grand jewel of entertainment for Black America" by Georgie Woods, who promoted concerts there and was a radio personality and civil rights activist. The Uptown closed in 1978. Since then, every attempt to revive it has failed. A first-run movie theater was reestablished but soon failed. It reopened as the NU-TEC, a nightclub that aimed to be the Grand Ole Opry of R&B in 1982, but that failed a year later, even with $3 million in support from federal and city sources. The building was sold by the U.S. Small Business

Administration to recoup its losses, for $402,000 in 1985. It was purchased by real estate developer Willard Rouse III, who partnered with a group of black investors who planned to restore the building into an arts and culture complex that would include neighboring buildings. It looked to be a promising rebirth when the group held Africamericas Festival '87, which highlighted young talent from the city. However, a failure to partner with the city on the $18 million project doomed it. The building was sold to a church which used it from 1990 to 1994, but it has remained vacant since. In 2002 it was purchased by the Uptown Entertainment and Development Corporation, a community development nonprofit. The organization hopes to attract a variety of tenants, from a theater, recording studio, and technology center, to a high school and restaurant for the 50,000 square-foot landmark. The group has restored the facade and replaced its windows and completed the first phase of interior renovations for its youth programs. It has yet to raise enough funds to restore the auditorium.

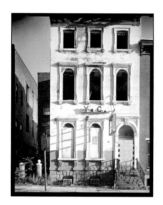

The Philadelphia Pyramid Club
1517 West Girard Avenue
W. Price, architect, 1879
Photograph, 1999

The Pyramid Club was a private, black social and cultural center founded in 1937. By 1940 it had grown and purchased this large brownstone mansion as its headquarters. The club supported the arts by highlighting a single artist each year. It was extremely influential during its height, hosting banquets, conferences, lectures, musical concerts, art exhibitions, and social events. Disputes among the members led to its bankruptcy and then closure by the IRS in 1963. From 1965 to 1981, the building served as the Columbia Branch of the YWCA. After the YWCA's departure, the building stood vacant until converted into a luxury residence and sold for just over $1 million in 2010.

Religious Buildings

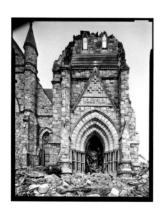

Christ Memorial Church
43rd Street and Chestnut Street
Isaac Pursell, architect, 1886
Photograph, 2004

The immense, 170-foot steeple of this church collapsed in August 2004 after being struck by lightning. The collapse forced the closing of the church's shelter for one hundred homeless women and children and its elementary school, and the relocation of the congregation. In 2007, after settling with its insurance company for $7.3 million, the church sold the building to a local developer. Part of the building still shelters several dozen homeless mothers and their children while a commercial tenant is sought. There are no restrictions that would forbid a new owner or tenant from demolishing the building "by right." In 2011 a Preservation Alliance survey identified 745 religious

buildings (not all churches) in the city, of which 721 were built before 1950. Many of these will likely be demolished in the coming years.

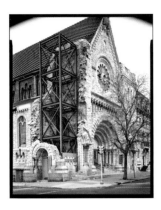

Our Lady of Mercy Church

2137–2159 North Broad Street
Edwin Forrest Durang, architect, 1893
Philadelphia Register of Historic Places
Demolished, 1997
Photograph, 1995

Many of Philadelphia's houses of worship that were built more than seventy-five years ago have a particular look: it is the abbreviated spire. Because many congregations in the city have fallen on hard times, the maintenance of their buildings has been neglected. These capped steeples or spires are a testament to that decline. This Catholic church was closed in 1984; its parish had shrunk to 264 congregants from 1,693 in 1953. Bible Deliverance Evangelistic Church purchased the property in 1986. The city shored up the tower after it collapsed into Broad Street in 1991. In 1995 the adjacent school building was demolished. Much of the rich ornamentation had been stripped away before the archdiocese foreclosed on the church in 1997. A developer settled the city's liens and purchased the church and its former school building site. Within nine months, the new owners had the church demolished and a city ordinance vacated Watts Street, which lay between the school and church. Shortly afterward a new Rite Aid store with a fifty car parking lot filled the newly created lot lines.

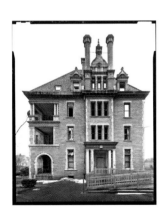

The Nugent Home for Baptists

221 West Johnson Street
J. Franklin Stuckert, architect, c. 1895
National Register of Historic Places
Philadelphia Register of Historic Places
Photograph, 2004

The Nugent Home is an early example of a movement begun at the end of the 19th century to establish retirement homes for professionals. The massive Châteauesque style suggests a noble family residence, though the home was designed to house thirty-eight retired ministers. The Nugent Home and its neighbor, the Presser Home for Retired Music Teachers, were purchased by an investor group in 1980 and converted to an assisted living residence for the elderly with mental disabilities. The facility was forced to close in 2002 due to the deteriorating conditions of the buildings and grounds and to the poor care and abuse of the residents, all of which were reported in media exposés. When a local church group proposed demolishing the Nugent Home, local residents and the Preservation Alliance of Greater Philadelphia rallied to have both buildings listed on the Philadelphia Register of Historic Places. Nolen Properties, the new owner, received a $2.6 million loan from the city in addition to a state grant of $11.5 million in the form of Low Income Housing Tax Credits and Investment Tax Credits for Historical

Rehabilitation—both forms of which the developer can sell to raise funds for the restoration of the building as an age-restricted residence.

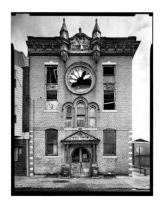

B'nai Moshe Anshe Sfard Synagogue

1711 South 5th Street
Architect unknown, 1904
Demolished, 2004
Photograph, 1998

Built in 1904 by Jews from Austria-Hungary, this synagogue was active until 1981. By the mid 1980s, South Philadelphia's once sizable Jewish population had shrunk to a tiny minority. After the building had been vacant for nearly a quarter-century, the city ordered it torn down in 2004.

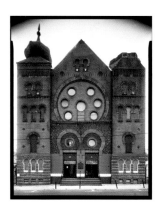

Adath Jeshurun Synagogue

1705–1713 North 7th Street
Franklin J. Stuckert, architect, 1888
Philadelphia Register of Historic Places
Photograph, 2002

This flamboyant, Moorish styled synagogue is a testament to the progressive nature of Philadelphia's Jewish community. The original congregation first moved to this site in 1888 from a rented hall at Third and Brown Streets, which it occupied since shortly after its founding in 1858. The congregation moved to Broad and Diamond Streets in 1911 and sold the synagogue to Congregation Ohel Jacob. At this time, the Jewish population in the city was over 100,000; by 1920 it had increased to nearly a quarter-million. By the late 1950s, many members of the congregation had moved to the northern suburbs, and in 1964 the synagogue followed them there. In 1967 the building was sold to Shalom Baptist Church, which in turn sold it to Greater Straightway Baptist Church in 1982, which continues to carry on its mission there and struggles to restore the building.

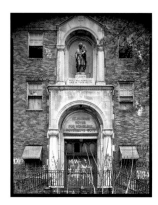

Saint Joseph's House for Homeless Industrious Boys

1515–1527 Allegheny Avenue
Peter Getz, architect, 1940
National Register of Historic Places
Photograph, 1994

This orphanage was established in 1888 and moved to the Allegheny Avenue location in North Philadelphia in 1940. Since the 1970s, the Catholic Archdiocese of Philadelphia has withdrawn from many parts of the city, selling dozens of churches, schools, and related structures. After lying vacant for more than a decade, this building was sold in 1995 and has been converted by a developer into an assisted living center.

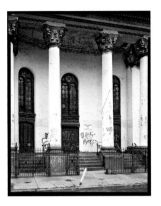

Green Street Methodist Church

1003–1011 Green Street

Architect Unknown, 1854

Demolished, 2000

Photograph, 1995

This church may have been the work of Joseph Hoxie. It closely resembled his Arch Street Presbyterian Church of 1855, an important architectural landmark in Center City. The original congregation disbanded in the 1940s. It was renamed the Methodist Memorial Church in 1947. The neighborhood has seen its housing stock shrink through neglect and vacancy during the second half of the 20th century, and this elegant church failed to reestablish itself. With funding provided since the establishment of the Pennsylvania Lottery in 1972, the church served as a senior citizen center for just over twenty years. Like many church buildings in Philadelphia, it lacked an historic designation. It was demolished in 2000 to provide ground for a forty-unit apartment building for seniors, which opened in 2005.

Fairmount Park

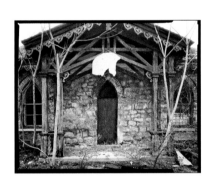

Sedgeley Porter's House

Sedgeley Drive

Benjamin H. Latrobe, architect, 1799

Philadelphia Register of Historic Places

Photograph, 1995

Originally this building was the gatehouse for the Sedgeley Estate, which was built by Benjamin Latrobe, considered by many the father of American architecture. The structure is significant because it is thought to be the first use of Gothic Revival style in domestic architecture in the U.S. The estate was donated to Philadelphia in 1854 and was instrumental in the creation of Fairmount Park the next year. The main house was demolished in 1857, but the gatehouse remained and was later used as a police station and jail by the Fairmount Park Guard. It had been abandoned for many decades and was to be demolished by the city in 1992. It was saved thanks to the creation by City Council of the Fairmount Park Historic Preservation Trust (FPHP), which helps to make up for the lack of park funds for the maintenance of its important buildings and structures. Formed in 1992, the FPHP is a nonprofit organization, which according to its mission statement "provides leadership, technical assistance, and advocacy to preserve, develop, and manage historic properties and other cultural resources in Philadelphia's Fairmount Park." Sedgeley, the first project initiated by the trust, was restored and became offices of the FPHP in 1995.

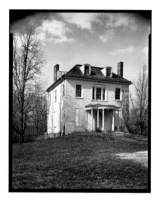

Rockland Mansion

Mount Pleasant Drive
George Thompson, architect, c. 1810
Philadelphia Register of Historic Places
Photograph, 1996

This building is an excellent example of Federal Period villa architecture and is unchanged in appearance since its construction. Built on a twenty-six-acre plot by its owner, George Thompson, a successful dry-goods merchant, it has suffered long periods of abandonment since an employee of the city and his family vacated it as their residence in the late 1970s. In 2002 the Fairmont Park Historic Trust found a tenant to help it raise funds to renovate the building and occupy the home for offices and events for the Psychoanalytic Center of Philadelphia. The renovations were completed in 2005.

Since 1992 the park's maintenance of its historic buildings has been shifted from its general operations to that of a nonprofit organization, the Fairmount Park Historic Preservation Trust. Its main goal is to find tenants who promise to historically renovate and maintain the property in exchange for free rent.

Until the late 1970s, the park made sure that most of its buildings of historic significance were occupied. The rent-free policy and the use of park employees and city funds to make repairs to the properties ended when the park had to begin charging the employees rent to use the properties. With the departure of the tenants, the park buildings, now empty, were soon in great need of maintenance, and many were lost to vandalism and arson.

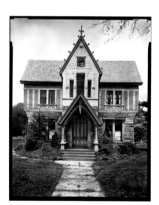

Ohio House

Montgomery Drive and Belmont Avenue
Heard & Sons, architect, 1876
Philadelphia Register of Historic Buildings
Photograph, 2005

Constructed with stone cut from twenty-one quarries in Ohio to showcase that state at the Centennial Exhibition of 1876, Ohio House is one of the two surviving buildings from that international fair. The building was renovated in 1976 but remained vacant until 2007, at which time it was leased through the nonprofit Fairmount Park Historic Preservation Trust to an entrepreneur who made needed renovations to the building and now operates it as the Centennial Café.

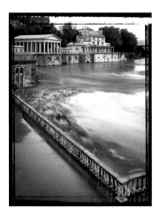

The Fairmount Water Works

Aquarium Drive
Frederick Graff, architect, 1812–1815, gardens, 1835
National Historic Landmark
National Register of Historic Places
Philadelphia Register of Historic Places
Photographs, 1997, 1996

The Water Works on the Schuylkill River was modeled after Roman temples and was the first major engineering triumph of the young republic. It was the sole provider of water to the city from 1815 until 1854. During the first half of the 19th century, the Water Works came to symbolize Philadelphia: images of it were reproduced in paintings and engravings and on porcelain and pottery. By 1899 industrial pollution made closure of the Water Works inevitable, and in 1909 its functions were replaced by other reservoirs. In 1911 the Water Works was given to the city and soon reopened as a public aquarium. By 1929 the aquarium was one of the largest in the world. Political maneuvering and inconsistent funding forced the aquarium to close in 1962. The Kelly Natatorium, a three-lane swimming pool, replaced the aquarium but closed permanently after a hurricane flooded the site in 1972. The pool had been named after John "Jack" Kelly, father of Grace Kelly and a three-time Olympic Gold medalist and great benefactor of Fairmount Park, as well as Commissioner of the park in the 1950s and 1960s. By 1984 the Water Works was included in a report to Congress by the Secretary of the Interior on damaged and threatened national landmarks. After three decades of on-and-off restoration, interspersed with long periods of neglect compounded by significant vandalism, the Water Works building's restoration was finally completed in 2005.

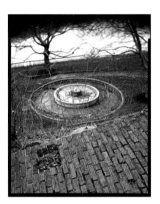

In 1829, when plans for expansion of industry adjacent to the Water Works were abandoned, the area at the foot of the Fairmount reservoir and south of the mill house was developed as a garden. A marble fountain, topped by the statue Boy and Dolphin, was the centerpiece of the new space. The gardens framed one of the great wonders of the world. Charles Dickens in 1840 called the Water Works ". . . no less ornamental than useful, being tastefully laid out as a public garden, and kept in the best and neatest order." As a young man, Mark Twain who in 1853 worked briefly at the Philadelphia Inquirer as a typesetter, wrote after visiting the Water Works, "I like this Philadelphia amazingly . . . Seeing a park at the foot of the hill, I entered—and found it one of the nicest little places about." After being forgotten for 40 years, this small garden, which was part of the original seed that sprouted into Fairmount Park, was finally restored and replanted in 2007.

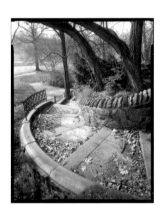

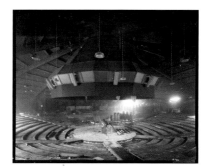

Playhouse in the Park

Belmount Plateau
Paul Henon, architect, 1956
Demolished, 1997
Photograph, 1997

Built on the site of an old bandstand, this 1,500-seat theater-in-the-round opened in 1956 as the first city–owned and operated theater. It began as a tent theater initiated by John "Jack" Kelly in 1952 so Philadelphia theatrical performances could continue through the warm summer months, a period when the city's theaters were closed. Later named in Kelly's honor, the theater was extremely popular for two decades. In 1963, forty theater companies bid to lease the theater for their summer performances. It closed in 1981 and was later leased to a couple in 1985 who ran the Marionette Puppet Theater. They could not maintain the theater but performed in an adjacent structure for eleven years. In 1993 one of the partners died, and the grounds became overgrown, leading the park to terminate the puppet theater's lease. In 1997 the site was demolished to make room for picnic grounds.

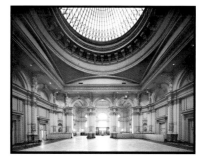

Memorial Hall

North Concourse Drive and Memorial Hall Drive
National Historic Landmark
National Register of Historic Places
Philadelphia Register of Historic Places
Photograph, 2005

The only surviving exhibit hall from the Centennial Exhibition of 1876, this monumental Beaux-Arts building was the Art Gallery for the world's fair and later served as the city's Museum and School of Industrial Art until 1928. Memorial Hall was used as a model for the Reichstag building in Berlin. From 1958 it housed offices for the Fairmount Park Commission. In 1964 the somewhat dark and crumbling building hosted a recreation center, which made use of its east wing for an Olympic size swimming pool and its west wing for a basketball court. The basketball court also served as the recording home of the Philadelphia Orchestra from the mid 1980s to the early 1990s. A police station used part of the building from 1982.

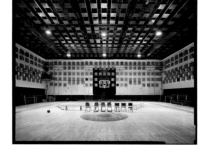

Due to severe underfunding, the Fairmount Park Commission was never able to maintain the building, and it had been in a deteriorating state since the museum departure. After nearly three years of renovations, Memorial Hall was monumentally reborn in 2008 as the new home of Philadelphia's Please Touch Museum for children and again has become a widely visited and cherished building.

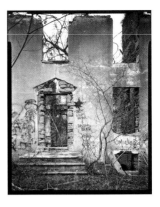

The Cliffs

Near 33rd Street and Oxford Street
Joshua Fisher, builder, 1753
National Register of Historic Places
Philadelphia Register of Historic Places
Burned, 1986
Photograph, 2005

The Cliffs was the summer residence of the Fishers, a prominent Philadelphia Quaker family. It was once thought of as one of the most important historical homes in Fairmount Park, if not the entire city. Its design was considered perfect and was emblematic of wealthy Quaker residences of the time, with a plainly appointed exterior that concealed a richly detailed interior. The building had been vacant for many years and was deteriorating. Plans by the park to demolish the structure were thwarted; throughout the 1970s and early 1980s, the boarded-up house remained neglected. The valley that lay behind the house was illegally filled with earth and rock excavated from construction of the Center City Commuter Tunnel between the late 1970s and early 1980s. When fire struck the house in 1986, the fire trucks responding to the call sank into the fill, preventing them from reaching the scene. The Cliffs was the third historic home lost to fire in a year. Wakefield House (1796) and Greenland (1825) both burned several months before.

The Park Commission rejected the advice of the architectural firm it had hired to assess the site and refused to stabilize what remained of The Cliffs. The ruined shell stands today, its basement kitchen and pantry sometimes occupied by the homeless. The disbandment of the Fairmount Park Guard's 525 officers (many of whom lived in Park houses) in 1972 was a watershed in the history of the park. A long legacy of vandalism, stolen property, arson, illegal dumping, and violent crime has followed.

Drinking Fountain, Wissahickon Valley Park

Forbidden Drive and Rex Avenue
Photograph, 2005

In 1845 a turnpike was cut through the Wissahickon Valley creating a convenient approach from the northwest into the city. With the greater access, this beautiful valley with its splendid views became a popular attraction. It was also an important early industrial site, with many mills along the banks of the creek, which spawned the country's first paper industry. This springhead, built in 1854, was one of several built along the road that carry the inscription "Pro Bono Publico. Esto Perpetua." For the good of the public. Let it remain forever. Like the Water Works before it, the fountain had to be sealed in 1954 because of contamination from polluted runoff.

Acknowledgments

I am fortunate to have Paul Dry publish this book. Without his patience and confidence in this project it may never have been completed as it exists now. I would like to thank Ken Finkel and John Gallery for their careful attention and thought they gave to my work. I also would like to thank Peter Barberie, Inga Safron, The Pew Fellowships in the Arts, The Center for Emerging Visual Artists, Dermot Mac Cormack, Mirai Yasuyama, Ursula Hobson and Robert Venturi and Denise Scott Brown for their support, advice and encouragement.

I would also like to thank The University of the Arts and Sean Dyroff for their technical support. For assistance with elements of historical detail I would like to thank Kenneth Milano, Andrew Fearon and Richard Boardman.

I am truly grateful for the love and support of my wife Kaori Ikeuchi who helped see me through this project from the very beginning. To my family, especial my Mother, Immie Feldman, my Aunt, Livia Corman, my children Kai and Yuma and to the memory of my Father, Harold Feldman who's inquisitive nature I am proud to carry forth.

Technical Note

The photographs in this book were created using a 4 x 5 inch view camera. This camera affords the most control over a photograph's geometry and focus when used for architectural subject mater. Often when photographing tall subjects the film is partially positioned into the outer regions of the lens projection. This results in photographs that exhibit a vignette and loss of sharpness much like we experience when viewing something out of the corner of our eye. Three photographs (on pages 55, 82, and 104) in this book were made by digitally compositing two negatives made from a single lens vantage point exploiting the large image circle created by the lens projection.

The film type used for the majority of this project is Kodak Technical Pan Film a film introduced in 1977 for astronomy, electron microscopy and other technical applications. The film is considered by many to have the highest resolving power of any commercially available film. It also has unique tonal characteristics that help reveal details, particularly in masonry. The black boarders around the photographs are the unexposed film edges and show the distinctive marks of the film holders that are loaded with individual sheets of film. Occasionally, Polaroid Type 55 film was used and can be identified by its perforated and imperfect film edge. This film allows photographic negatives to be processed and examined in the field. The delicate nature of this negative is sometime revealed as in the Francis M. Drexel School (page 45) which shows damage in the sky which occurred during transportation from the location.